IMAGES
of America

BERKELEY AND THE NEW DEAL

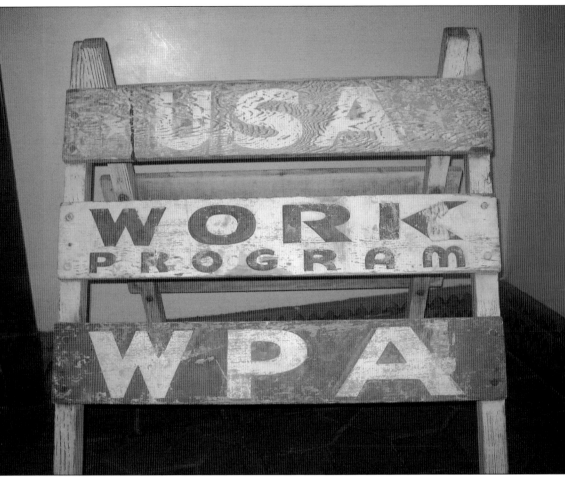

During the Great Depression, America experienced an economy in free fall, 25 percent unemployment, widespread hunger, homelessness, and the environmental catastrophe of the Dust Bowl. Our government's response for the stricken nation was unprecedented—an all-out investment in getting America back on its feet. This WPA original sawhorse is a telling emblem of the 8.5 million jobs that were created throughout the United States just by the Works Progress Administration. In Berkeley, WPA workers were employed from the Bay Shore Highway to the laboratories on the University of California campus. The sawhorse is in the collection of the Berkeley Historical Society. (Author's collection.)

ON THE COVER: In this publicity photograph, WPA workers and East Bay Regional Park District staff put finishing touches on the roof of the Brazilian Room in Tilden Park. The interior of the building is paneled with wood from the Brazil Pavilion of the Golden Gate International Exposition, the 1939–1940 world's fair on Treasure Island. (The island was created on shallow shoals in San Francisco Bay by the WPA.) This image is a visual symbol of the close working relationship of the WPA and local government agencies. (East Bay Regional Park District.)

IMAGES
of America

BERKELEY AND THE NEW DEAL

Harvey L. Smith

2/18

To Peter,
 Thanks for your support.
All the best!
 Harvey

ARCADIA
PUBLISHING

Published by Arcadia Publishing
Charleston, South Carolina

Printed in the United States of America

Library of Congress Control Number: 2014936555

For all general information, please contact Arcadia Publishing:
Telephone 843-853-2070
Fax 843-853-0044
E-mail sales@arcadiapublishing.com
For customer service and orders:
Toll-Free 1-888-313-2665

Visit us on the Internet at www.arcadiapublishing.com

To the memory of socially active, dear friends who passed last year: Erick "Amunka" Davila, Roberto "Jose" Garcia, and Willard Harris Jr. They left us in 2013, but each contributed a wonderful legacy to the Berkeley community.

CONTENTS

FOREWORD

A dozen Berkeley citizens gathered on February 6, 2009, to toast men whose names they did not know. Precisely 75 years before, those men had left the city a gift of the tennis court in which the glasses clinked. But unlike so many of the New Deal's public works legacies, they had taken pains to sign their work in stone as a token of their own gratitude for the gift they had been given.

Local historian Steven Finacom had found an article in the *Berkeley Daily Gazette* from the day the court in Codornices Park was dedicated. It notes that the workers had pooled their "meager income" to pay an unemployed stone carver to inscribe the initials "C.W.A." and the date "1934" on two polished granite slabs. They cemented the stones into a retaining wall since, the work crew foreman told a reporter, "the men working under him wanted to leave some memento to the City and the Federal Government for the efforts that had been made to secure work for them."

Few Americans in 2009, however, could identify the Civil Works Administration as a short-lived trial run for the more famous Works Progress Administration, let alone name a single public work created by the CWA to help millions of families through the darkest winter of the Great Depression. Almost none of those projects were signed but this one.

Harvey Smith has, in the photographs and text of this book, memorialized more than the physical legacy left to one American town by a spectrum of federal work relief agencies, for to remember them is to revive also the *ethical* vision with which ingenious and compassionate leadership once infused the nation.

Sculptor Robert Boardman Howard embodied that vision in a monumental relief that climbs the exterior of the Berkeley Community Theater. The sculpture faces Civic Center Park, for which the WPA also paid. Howard depicted people of all races, brought together by the performing arts. The arts, too—along with the sewers, schools, street trees, and tennis courts—sought to improve public health in all dimensions and did so for generations. This book is a toast to the forgotten men and women whose innumerable gifts we have for so long unwittingly enjoyed.

—Gray Brechin, author of *Imperial San Francisco: Urban Power,*
Earthly Ruin and founder of the Living New Deal

ACKNOWLEDGMENTS

This book started with my 2010 exhibit at the Berkeley Historical Society, *The 75th Anniversary of the WPA in Berkeley*. Just as the New Deal was a collaborative effort, so was putting together that exhibit. Thanks again go to those who helped create the genesis of this volume. All of the following contributed research, photographs, time and/or materials: John Aronovici, Susie Bailey, Alan Bern, Gray Brechin, Steve Finacom, Jef Findley, Sgt. Michael Holland, Susan Ives, Travis Lafferty, Will Maynez, Ron Partridge, Rebecca Schnier, Dale Smith, Margot Smith, Allen Stross, Diana Yoshida and Yoshiko Yoshida. The research done for my 2011 paper prepared for a conference at Hofstra University, "The Monkey Block: The Art Culture of the New Deal in the San Francisco Bay Area," also informs this present work and parts of the introduction are taken from it. For that effort, I thank Mary McChesney, Rondal Partridge, Milton Hebald, Gertrude Goodrich, Beth Danysh, Julia Bergman, Ruth Zakheim Gottstein, Masha Zakheim and Nathan Zakheim. As I did then, I will dedicate this to the memory of those who found productive work through the New Deal: Thomas Fleming, Toby Cole, Milt Wolff, Archie Green, Stetson Kennedy and Studs Terkel. More recently, I want to acknowledge the assistance of Stuart Wittenstein, superintendent of the California School for the Blind; Brenda Montano, East Bay Regional Park District Archive Room; Richard Langs, historian of the East Bay Regional Parks; Kay Peterson, Archives Center, National Museum of American History, Smithsonian Institution; Susan Snyder and the librarians at the University of California Bancroft Library; Kathleen Duxbury, historian of the CCC arts program; Jef Finley, Berkeley Public Library's Berkeley History Room; Anthony Bruce, Susan Cerny, and Daniella Thompson, Berkeley Architectural Heritage Association; John Aronovici and Therese Pipe, Berkeley Historical Society; Cathy Kerst and Ann Hoog, Library of Congress American Folklife Center; Christine Cheng, George Mason University Special Collections and Archives; John Mann, City of Berkeley Parks, Recreation & Waterfront; Dave Smith, University of California Museum of Paleontology; Susie Naye, for her enthusiastic encouragement; and Margot Smith, for reviewing my draft. I appreciate the support and encouragement of my acquisitions editor Jared Nelson at Arcadia Publishing. Thanks go also to all my colleagues of the National New Deal Preservation Association and the Living New Deal for their interest, encouragement and activism.

Unless otherwise noted, all images appear courtesy of the author. Other images in this volume appear courtesy of the Berkeley Architectural Heritage Association (BAHA), the National Archives and Records Administration (NARA), the East Bay Regional Park District (EBRPD), the Berkeley Police Department Historical Unit (BPDHU), the Berkeley Public Library (BPL), the Berkeley Historical Society (BHS), the Library of Congress, Prints & Photographs Division, FSA/OWI Collection (FSA/OWI), the University of California Museum of Paleontology at UC Berkeley (UCMP), and the WPA California Folk Music Project Collection, 1938–1940 (AFC 1940/001), American Folklife Center, Library of Congress (LOC).

INTRODUCTION

In the 1920s, the United States economy was booming, but there was a wide gap in income between rich and poor Americans, just as now. Then, the economic collapse began with the 1929 stock market crash. The ensuing Great Depression left millions unemployed. There was no social safety net—no bank deposit insurance, no unemployment insurance, no social security.

Franklin Delano Roosevelt, accepting the nomination of his party in 1932, pledged "a new deal for the American people." Later, he would state, "The test of our progress is not whether we add more to the abundance of those who have much; it is whether we provide enough for those who have too little." This statement sums up the direction of the New Deal: Main Street before Wall Street. But then, just as now, the political Right vigorously opposed Main Street progress.

People may argue over statistics about what the New Deal accomplished, but two things are needed to understand it clearly: first, that people who participated in or benefitted from the New Deal tell the real, firsthand story; and second, that the New Deal's physical legacy still surrounds us (mostly unrecognized) as buildings, bridges, roads, and public art—a visual landscape that we enjoy and depend on today.

In the first Hundred Days of FDR's administration, 15 major pieces of legislation were passed to address the problems created by the economic collapse. Among this so-called alphabet soup of programs was the Civilian Conservation Corps (CCC), which ultimately employed 3.5 million unemployed youth and planted 3 billion trees. Another program gave long-term mortgage loans to some one million homeowners to prevent foreclosure. The Glass-Steagall Act separated commercial and investment banking and established the Federal Deposit Insurance Corporation (FDIC) to insure customers' deposits in banks and thrift institutions. The Public Works Administration (PWA) built massive infrastructure projects, such as dams, bridges, and schools.

After the Hundred Days, a myriad of other federal programs were created. Because regulating corporate excesses was critical, the Securities and Exchange Commission (SEC) was established to oversee stock market trading. The Federal Communications Commission (FCC) was formed to maintain electronic communications in the public interest.

Thousands of families were provided housing in both urban and rural areas. One of these programs, the Farm Security Administration (FSA), also hired photographers—including Walker Evans, Dorothea Lange, Arthur Rothstein, Russell Lee, Gordon Parks, and others—to document the conditions of drought-stricken and financially ruined farm families.

Putting people to work in decent conditions and protecting them on the job were critical. The National Youth Administration (NYA) hired high school and college students for work-study and part-time work and provided vocational training and programs for out-of-school youth. The National Labor Relations Act (NLRA), also known as the Wagner Act, gave workers the right to organize and bargain collectively with employers over working conditions, benefits, and wages. A crowning social policy achievement of the New Deal was the creation of the Social Security Administration. In addition to welfare provisions, it created a social insurance program for retired workers age 65 and older and provided for unemployment insurance.

The first federal art program, the Public Works of Art Project (PWAP), was started in 1933. Later, the Treasury Department established two programs to adorn federal buildings by commissioning artists through a competitive process (known as the Section) and by directly hiring artists on relief (known as the Treasury Relief Art Project). Under the Section of Painting and Sculpture, artists signed contracts under the direction of the secretary of the treasury for the United States of America. The artists' work became property of the United States on behalf of the American people.

Probably the best-known New Deal program was established in 1935. The Works Progress Administration (administered by Harry Hopkins) hired 8.5 million people and built thousands of schools, parks, city halls, public libraries, recreational fields, streets, highways, sewers, airports, utilities, and more. The WPA/Federal Art Project included art, writing, theater, music, and history projects, much of which celebrated the dignity of work and working people. Many artists thought of this period as a new flowering of American art. Outspoken San Francisco sculptor Benny Bufano declared that the "WPA/FAP has laid the foundation of a renaissance of art in America."

Overall, the impact of the New Deal in the United States dwarfs any of the recent stimulus programs. Its massive investment in employment and infrastructure moved the country to true recovery. Note just some of its accomplishments: the Civilian Conservation Corps employed over 3 million and planted 3 billion trees; the short-lived Civil Works Administration employed 4 million people and constructed or repaired 4,000 schools, built or improved 254,000 miles of roads, hired 50,000 teachers for rural schools, built or improved 1,000 airports, and employed 3,000 artists; the Public Works Administration spent $6 billion (in 1930s dollars) in contracts to private construction firms to build roads, tunnels, bridges, dams, hydroelectric-power projects, public buildings, hospitals, schools, and municipal water and sewage systems; the Works Progress Administration employed more than 8.5 million and built or improved 2,550 hospitals, nearly 40,000 schools, 85,000 public buildings, over 1,000 airports, 639,000 miles of highway, 124,000 bridges, 8,000 parks, and over 18,000 playgrounds and athletic fields; and the National Youth Administration employed nearly 5 million youth.

Later, FDR outlined his program for post–World War II in his 1944 State of the Union address. He proposed a "Second Bill of Rights" that recognized inherent human rights, including employment, housing, medical care, and education. FDR died before he could implement his "economic bill of rights" proposal. However, his New Deal programs did provide long-range public investment, which lifted communities all across the United States. We are still benefitting from these infrastructure and social programs three-quarters of a century later.

Soon after FDR's death in 1945, political attacks on the New Deal heightened. Three key areas were affected by New Deal deregulation: labor, media, and finance. The National Labor Relations Act was initially weakened in 1947 by the Taft-Hartley Act. Beginning in the 1980s, a weakened FCC allowed the current monopolization of the media. Many economists, including Nobel Prize winners Paul Krugman and Joseph Stiglitz and former secretary of labor Robert Reich, cite the 1999 dismantling of the Glass-Steagall Act as a primary cause of the 2008 financial meltdown.

The New Deal was clearly the result of the combination of intelligent and inspired leadership at the top and public discourse, enormous activism, and unparalleled creativity at the grassroots. It established a new social contract that raised many Americans to middle-class living and to higher cultural standards. Today, we should ask the question, "Where did it go?" Reflecting on the scope of New Deal programs today shows how much the vast majority of ordinary Americans has now lost and how we must revive the movement toward greater social equity and economic democracy and, perhaps, foster another artistic renaissance.

In Berkeley in the 1930s and early 1940s, New Deal structures and projects left a lasting legacy of utilitarian and beautiful infrastructure. These public buildings, schools, parks, and artworks helped shape the city and thus the lives of its residents. It is hard to imagine Berkeley without them. In oral histories, artists and architects involved in these projects mention several themes: working for the community, responsibility, the importance of government support, collaboration, and creating a cultural renaissance. But, the work of the New Deal can also be called a "hidden history" because its legacy has been mostly ignored and forgotten. Comprehending the impact

of the New Deal on one US city is only possible when viewed as a whole. Berkeley might have gotten a little more or a little less than other towns, but this time it is not "Bezerkeley"—it is very much typical and mainstream.

In the 1930s, Berkeley was one of nearly a hundred cities in the United States that was between 50,000 to 100,000 in population. Berkeley voted Republican and, in fact, harbored a vigilante committee that beat up supporters of the San Francisco General Strike in 1934—not today's characterization of the city as the bastion of free thought. But like so many other cities, it received its fair allocation of New Deal projects.

This book's thrust is not only to show how those projects affected one city, but also to highlight the New Deal period's relevance to today's social, political, and economic realities. The times may again call for comprehensive public policy that reaches Main Street.

The fate of one of those Main Street institutions, the Downtown Berkeley Post Office and its New Deal mural and bas-relief, has raised the concern of Berkeley residents and local elected officials. Due to the determined rush of the United States Postal Service (USPS) to sell postal facilities, this concern extends also to the over 1,100 New Deal post offices and the artwork displayed in over 1,000 post offices nationwide in both New Deal and earlier-constructed postal buildings.

Normally, when government buildings and property are decommissioned, they revert to local government ownership. However, in the case of the USPS, this normal practice has been subverted since the passage of the Postal Reorganization Act of 1970, which abolished the US Post Office Department and its cabinet-level postmaster general. The USPS became a hybrid agency, still controlled by Congress but also semi-independent, neither wholly public nor entirely private.

The 1970 act contains the phrase "public interest," implying the intention of Congress that the newly formed USPS would remain an agency that continued to serve the public in the fullest sense. In terms of postal property, US code states that the USPS can transfer property to other federal departments if it serves the public interest. However, preservation of historic assets within the public sector should also be defined as in the public interest, and Presidential Executive Orders 12072 and 13006 make explicit the importance of historic federal properties in our cities.

The extension of the public trust doctrine, which usually is applied to waterways, has also been suggested as applicable to postal and other federal properties. That government should be the steward for what the American people value and have paid for through taxation is totally logical. This calls into question the USPS viewing its authority to include the selling to private parties the historic public resources of our nation.

The architecture and artwork in post offices were part of the New Deal's effort to democratize culture. Contracts with artists for artwork were between the artists and the United States of America under direction of the secretary of the treasury. The completed artwork was to "become the property of the United States."

The Berkeley community views the sale of the post office as a theft of historic public assets and a betrayal of the values under which it was originally created. The denial of the expected stewardship responsibility for it by a governmental agency ignores the importance of the architecture and artwork as a cultural heritage owned by the American people.

As this book is completed, we await the outcome of the struggle to preserve the post office and its artwork in its original state and for its intended purpose.

One

DEMOCRATIZING
RECREATION AND
CREATING PARKS

During the Great Depression, New Deal programs built and improved parks on the national, state, county, and city levels. Park projects not only put people to work, but were designed to democratize recreation—that is, to make recreational activities available to everyone. The National Park Service (NPS) describes the economic crisis of the Depression as actually spawning "the greatest booms in construction of visitor facilities, road and trail development, park planning, identification of new areas, and new initiatives for expansion of the system to ever occur." Public recreation projects were a high priority during the New Deal. They were thought of as a civic right, with new access created to swimming pools, tennis courts, and golf courses, which had previously been the privilege of the rich.

Most parks in Berkeley were improved or created by the New Deal. In December 1933, the Berkeley City Council approved a Civil Works Administration (CWA) plan that would include work repairing park equipment and buildings. First among these were Hinkle Park Amphitheater and the Codornices Park tennis courts (north of the yet-to-be-developed Berkeley Rose Garden). The Works Progress Administration (WPA) work spanned from the bay-shore yacht harbor and aquatic park to the rose garden in the hills. Major work was done by the Civilian Conservation Corps (CCC) and WPA at the University of California (UC) Berkeley Botanical Garden and in Tilden Park, including the Tilden Regional Park Botanical Garden, the golf course, Lake Anza, and the Brazilian Room. The CCC camp in Strawberry Canyon came first in 1933. In 1935, Camp Wildcat Canyon was established in what is now Tilden Nature Area. Capacity for CCC camps was generally 200 young men. CCC workers built roads, culverts, shelters, and picnic sites. Most of their skilled stonework remains today. Five hundred WPA workers built seven miles of Wildcat Canyon Road through Tilden Park.

Other areas were also improved. The CWA and WPA beautified many city parks and streets by planting trees. Finally, at the very end of the New Deal, the work on Civic Center Park was completed, and it was dedicated in 1942.

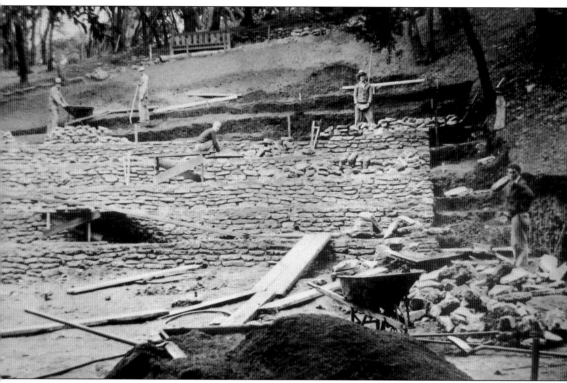

Construction of Hinkel Amphitheater shows the use of low-cost concrete rubble. The Civil Works Administration (CWA) was a short-term program over the winter of 1933–1934. However, it employed over four million workers, who built or repaired an impressive amount of infrastructure in a relatively brief period. In December 1933, the Berkeley City Council had approved a CWA plan to have 1,800 working in the city, using some $300,000 in funding from the federal government. City proposals for projects included "grading streets, constructing storm sewers, painting City Hall, and repairing park equipment and buildings," according to the *Berkeley Daily Gazette* in December 1933. (BAHA.)

Vernon M. Dean designed the amphitheater in late October 1933. In January 1935, Berkeley's city engineer reported that "25 CWA projects were supervised by [the] Bureau of Streets, using 27,000 man days of CWA labor, with no extra increase in regular personnel. CWA projects including grading 25 blocks of unimproved streets, widening 6 blocks of improved streets, constructing 775 feet of storm sewers, and repairs to 45,830 square feet of cement sidewalk." (BAHA.)

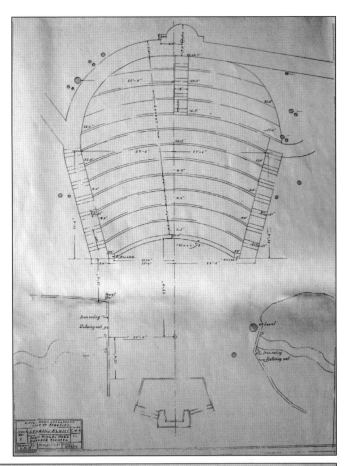

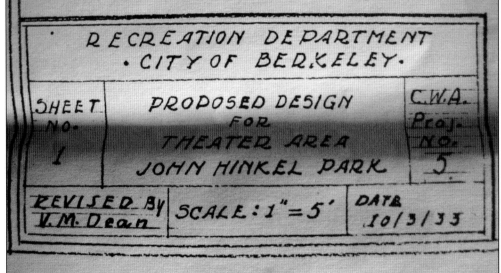

Like other New Deal projects, the amphitheater was built under the supervision of a local agency, the Recreation Department of the City of Berkeley. Vernon Dean, the city's landscape architect, later designed the Berkeley Rose Garden. (BAHA.)

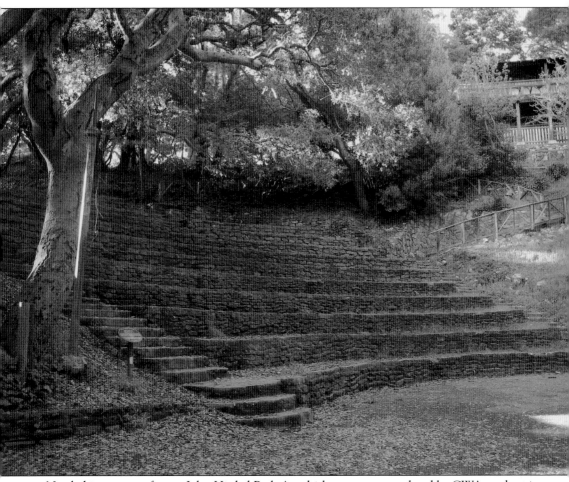

Nestled in a grove of trees, John Hinkel Park Amphitheater was completed by CWA workers in 1934. From 1934 to 1941, it was used regularly by a group funded by the WPA and the city. The Berkeley Shakespeare Festival used the amphitheater for 15 years until 1991, when it moved to a new site in Orinda.

The tennis courts are north of the rose garden. In the middle of the stone and rubble retaining wall are two plaques created by CWA workers. These marble plaques are unique.

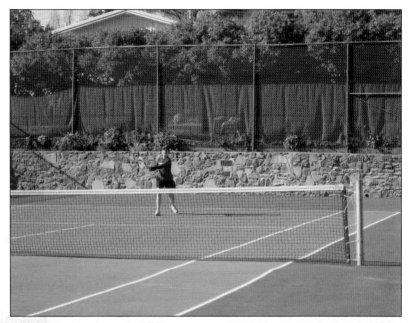

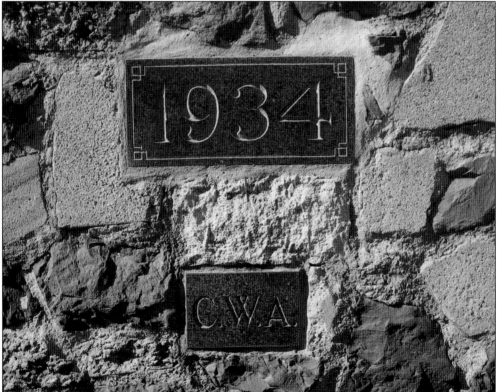

The CWA workers who built the wall pooled their funds to pay an unemployed stone carver to create these plaques. The *Berkeley Daily Gazette*, reporting on the court's dedication on February 6, 1934, notes that the workers "wanted to leave some memento to the City and the Federal Government for the efforts that had been made to secure work for them."

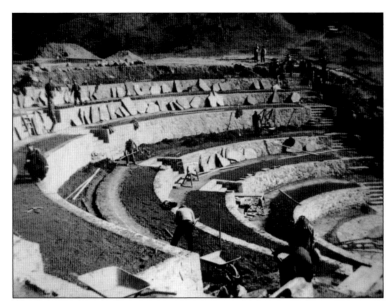

Work on the Rose Garden began in 1933 with funds provided by the CWA and was completed under the WPA. It opened on September 26, 1937. The site has magnificent views of the bay and the Golden Gate and is very popular for weddings. (BAHA.)

From shades of red at the top through bronze and pink to yellow and white at the bottom, the roses originally ranged down the hill one color per terrace. Roses have since been planted beyond the original six terraces. The terraces curve within the ravine formed by Codornices Creek, which emerges from a culvert at the bottom of the garden.

This plaque gives the completion date of the garden. The rose garden's 75th anniversary was celebrated by Berkeley citizens in September 2012.

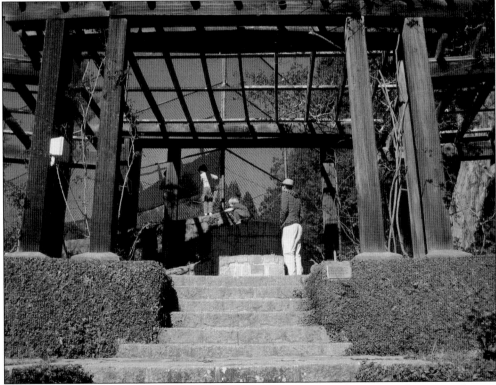

The WPA plaque can be seen to the right of the stairs. Hundreds of tons of native rock were quarried in the Berkeley Hills to construct the terraces.

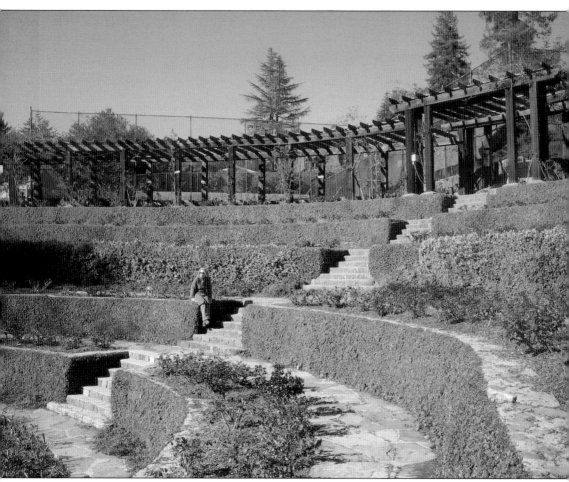

This view is just before the spring bloom. East Bay rose societies and community members donated hundreds of hours of volunteer time to complete the garden. The terraced amphitheater and 220-foot-long redwood pergola were suggested by famed Berkeley architect Bernard Maybeck. The final design and execution were the work of city landscape architect Vernon M. Dean and rose specialist C.V. Covell. Construction was supervised by Charles W. Cresswell of the Berkeley Parks and Recreation Department.

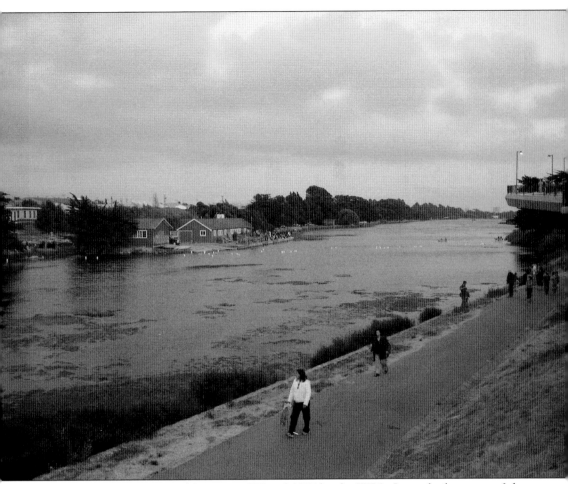

Aquatic Park was constructed between 1935 and 1937 by the WPA. It was built as part of the Berkeley Waterfront Project along with the construction of the Eastshore Highway and yacht harbor. Tide gates were constructed to help keep the water level constant in Aquatic Park Lake. A citywide celebration called Pageant of the Land and Sea was held on May 7, 1937, to formally dedicate the park for public use. Now known as the Bay Festival, it is still celebrated annually at the Berkeley Marina. The lights seen on the water are from paper lanterns floated across the main lake of Aquatic Park to commemorate the victims of the 1945 nuclear bombings of Hiroshima and Nagasaki. The Japanese Lantern Ceremony for World Peace has become an annual Bay Area tradition, with hundreds showing up to decorate the lanterns and watch from the shore.

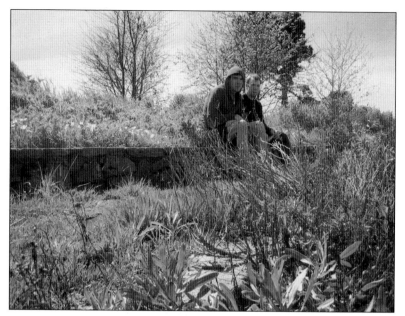

Two Berkeley natives and former graduates of Berkeley schools, Joshua Kennedy-Smith, research chemist (left), and Dasan Kennedy-Smith, baker and goat farmer, sit on the retaining wall benches that line the Model Yacht Racing Lake at Aquatic Park, built by the WPA in 1937.

This view of the bench retaining wall is facing the Eastshore Highway. Aquatic Park is a popular location for hiking, cycling, boating, bird-watching, and picnicking.

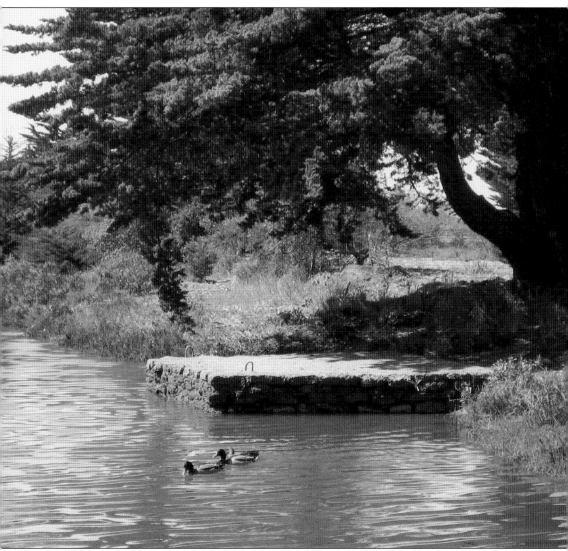

Aquatic Park Lake was designed to conform to international standards for model yacht racing and hosted both the National and Pacific Coast Regattas for M-class boats in 1938. This serene view shows a stone dock on the edge of the lake. A four-lane road that would bypass Berkeley on the west, known as the Eastshore Highway, was begun by local CWA workers, who were mostly drawn directly from the ranks of Berkeley's unemployed.

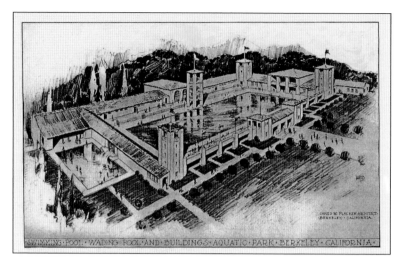

This sketch of an Aquatic Park project by James W. Plachek was proposed to WPA authorities. It would have rivaled the famed Sutro Baths in San Francisco. Cost of construction of the natatorium was $170,000, but it was not built. (BPL.)

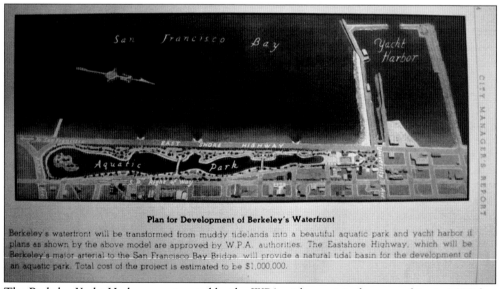

Plan for Development of Berkeley's Waterfront

Berkeley's waterfront will be transformed from muddy tidelands into a beautiful aquatic park and yacht harbor if plans as shown by the above model are approved by W.P.A. authorities. The Eastshore Highway, which will be Berkeley's major arterial to the San Francisco Bay Bridge, will provide a natural tidal basin for the development of an aquatic park. Total cost of the project is estimated to be $1,000,000.

The Berkeley Yacht Harbor, constructed by the WPA with municipal sponsorship, is 4,000 feet long and 1,600 feet wide, ranging from 4 to 30 feet in depth. Earthen walls with rock facing protect craft within. (City of Berkeley Parks Recreation & Waterfront.)

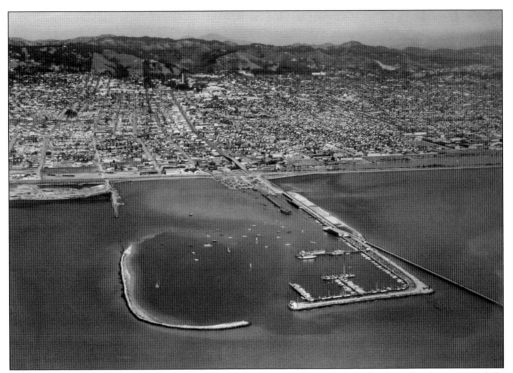

The long pier on the right was originally built three miles out into the bay for the automobile ferries to San Francisco. Superseded by the Bay Bridge, it became a fishing pier. The Berkeley Yacht Club officially came into being on April 28, 1939, and it joined the Pacific Interclub Yacht Association in 1939. The original club fleet included 11 sailing boats and 9 power craft. (City of Berkeley Parks Recreation & Waterfront.)

A 1936 city report states, "The transformation of the waterfront from an unsightly mud flat to a great Eastbay marine recreation center is under way." The Cal Sailing Club uses the present-day Yacht Harbor for its activities and is open to the public. It is a sailing cooperative for small-boat sailors and windsurfers—not a traditional yacht club, but a nonprofit that owns a fleet of 23 sailboats from 14 to 26 feet.

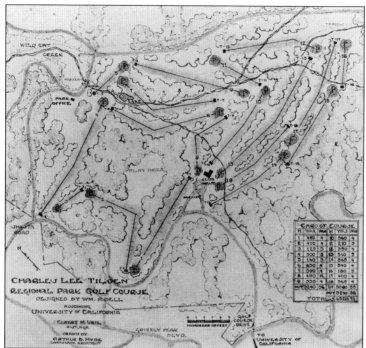

CHARLEY LEE TILDEN
REGIONAL PARK GOLF COURSE
DESIGNED BY WM. P. BELL
ADJOINING
UNIVERSITY OF CALIFORNIA
ELBERT M. VAIL
DIST. MGR.
DRAWN BY
ARTHUR D. HYDE
LANDSCAPE ARCHITECT

The East Bay Regional Park District provided a $63,000 match for $1 million in WPA funds to put 2,000 men to work, which included uprooting 20,000 eucalyptus trees to make way for the golf course. It was designed by William P. Bell, nationally known golf course architect and engineer. He was assisted by Richard E. Walpole, who was later to become park district manager. (EBRPD.)

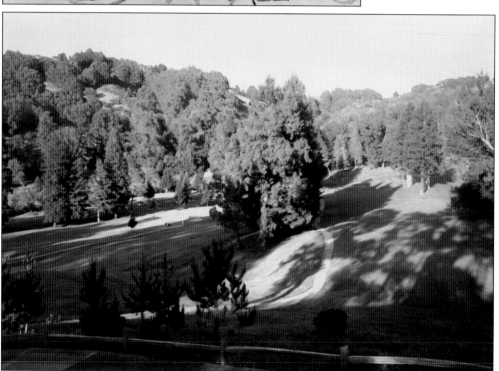

Begun in 1936, the course was opened to the public on November 11, 1937, after 18 months of construction. WPA labor provided for this work and of the total cost of $173,435, the sum of $138,943 was paid by WPA funds. Walpole promoted the course by writing a weekly golf column in the *Berkeley Daily Gazette*.

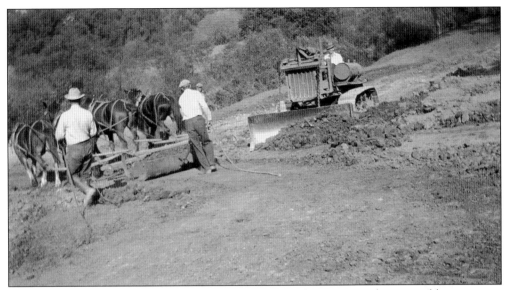

In 1938, the PWA financed the construction of Lake Anza for recreational activities like swimming and boating. The dam-formed lake was to be the centerpiece of the recreation area and would serve as a water source for the golf course across the road. This photograph portrays both older horse-drawn and newer motorized construction equipment. (EBRPD.)

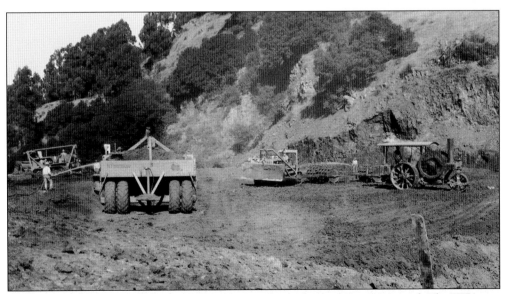

Lake Anza was constructed with newer tractors and one that was steam powered. The PWA was known to rely more on construction equipment, whereas the WPA emphasized hiring more people and working by hand. The lake was created by the construction of the C.L. Tilden Park Dam in 1938. Charles Lee Tilden was the first board president of the East Bay Regional Park District, and Tilden Park was named after him. (EBRPD.)

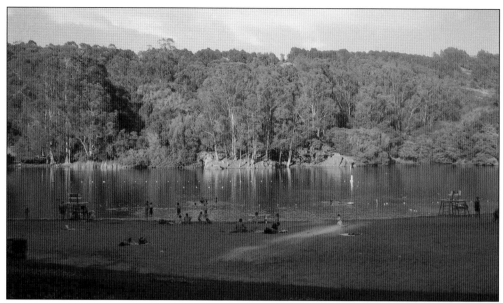

The WPA also worked on the Lake Anza site, constructing the bathhouse and hauling sand for the beach. On June 29, 1939, the park district manager was given the authorization to begin work on the bathhouse building, and it was completed in 1941. It has since been replaced by another bathhouse building.

This serene view of Lake Anza faces the swimming beach. The lake is open for swimming from May through September.

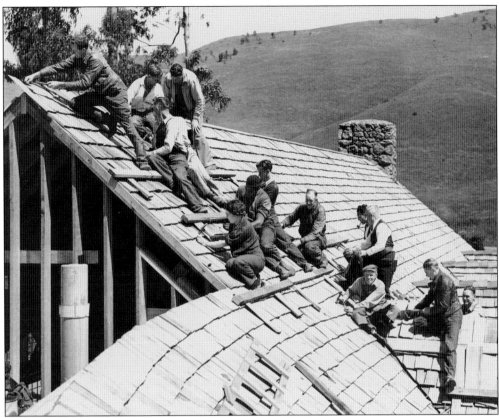

In this publicity photograph, WPA workers and East Bay Regional Park District staff put finishing touches on the roof of the Brazilian Room in Tilden Park. Among those pictured are the following: top left, Wes Adams, district supervisor who worked with WPA and CCC crews; sitting on roof facing away, Ralph Stilson, district workman; fourth from left standing and looking down, Richard E. Walpole, Tilden Park superintendent and later district manager; Georgette Morton, district manager's secretary; sitting behind Georgette, Buck Dunn, district equipment operator; standing in front of man with pipe and wearing vest, Elbert Vail, district manager from 1934 to 1942. Others are likely from the WPA crew, the real roofers. This image is a visual symbol of the close working relationship between the WPA and local government agencies. In the photograph below, construction is nearly complete in this back side view of the Brazilian Room. The park ranger's house is on the left. (Both, EBRPD.)

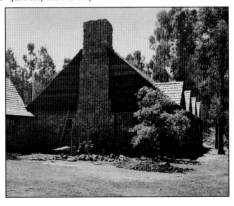

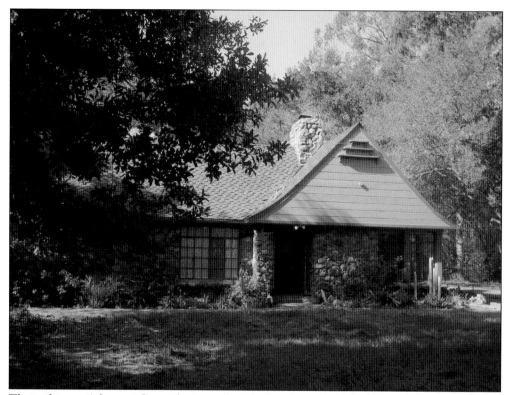

The park ranger's house is located next to the Brazilian Room in Tilden Regional Park. After the close of the Golden Gate International Exposition (GGIE), turf from the world's fair was used around the Brazilian Room and the golf course. The entrance of the Brazilian Room is seen in the photograph below. It derives its name from the use of interior paneling from the Brazilian Pavilion at the GGIE on Treasure Island. At the fair's end, the paneling was given as a gift of friendship from the Brazilian government. The English-style building utilized native stone and was erected by WPA employees. It was remodeled extensively in 1965 and is a popular location for weddings, receptions, clubs, and dinners, as well as a meeting place for organizations.

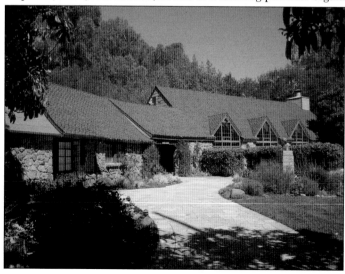

Dedicated on May 18, 1941, the Brazilian Room boasts interior paneling made of Brazilian hardwoods, such as jacaranda, imbuya, sucupira, and mahogany.

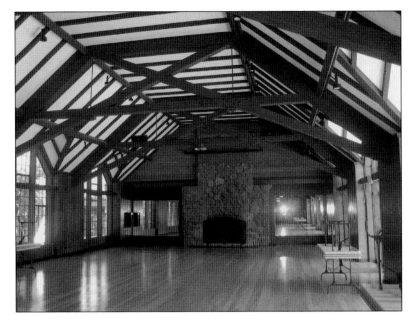

This rock wall in the Tilden Regional Park Botanic Garden was built by the WPA. Devoted to the collection, growth, display, and preservation of the native plants of California, the garden construction began in early 1939.

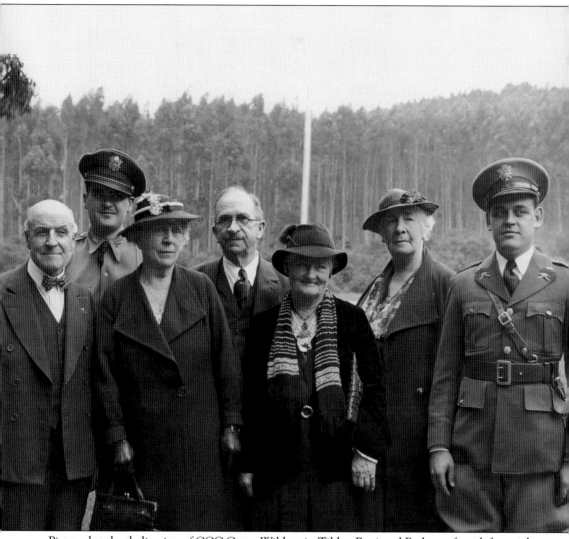

Pictured at the dedication of CCC Camp Wildcat in Tilden Regional Park are, from left to right, Thomas J. Roberts, secretary of the East Bay Regional Park District; Lt. Orvill Rouse, junior officer, CCC Camp; Mrs. Jessie Radcliff, president auxiliary to the Pioneers Association; T.P. Montgomery; Mrs. D. Wilson; Mrs. Brandt, past president of the Pioneers Association; and 1st Lt. Eugene R. Swarting, commanding officer, CCC Camp. (Not pictured are first park district manager Elbert Vail and park board director August Vollmer, the renowned former police chief of Berkeley.) During World War II, the Army used the abandoned CCC buildings. Following the war, local schools began to use the area for nature study. In 1949, the northern portion of Tilden was formally designated the Tilden Nature Area. A small nature center staffed with a full-time naturalist staff was established in the old Army barracks. In 1974, the old center was replaced by the Environmental Education Center, built on the site of the old CCC camp. Environmental education programs continue to this day. Next to it is the Little Farm, where children and adults can see and get close to farm animals. (EBRPD.)

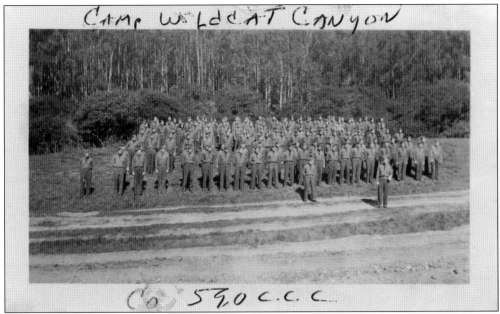

This photograph shows the Wildcat Canyon CCC Camp in formation in Tilden Park. Camp SP-33, Company 5446, was established on October 9, 1937, and Camp MA-3, Company 4429, was established on October 1, 1939. From 1936 until 1941, CCC crews developed not only Tilden Park but also Temescal and Redwood Regional Parks. The crews built picnic grounds, campsites, and restrooms; planted trees and eradicated undesirable growth; and built miles of roads and trails. The US Army ran the camps, but crews received their work assignments from collaborating agencies. (Civilian Conservation Corps Collection, Archives Center, National Museum of American History, Smithsonian Institution.)

This stone bridge was built by the CCC over Strawberry Creek in the UC Botanical Garden. The CCC camp was across the road from the garden. Company 751 occupied Strawberry Canyon Camp SP-10 from October 5, 1933, until May 31, 1934. WPA photographs from the late 1930s in possession of the Bancroft Library show CCC workers developing the UC Botanical Garden. A map (also in the possession of the Bancroft Library) shows the design of the garden, which contains plants from around the world. This map of the garden is dated November 1933 and is titled "Master Plan for University of California – Strawberry Canyon Project – Strawberry Canyon Camp S.P.10." It includes the locations of the buildings of the CCC camp.

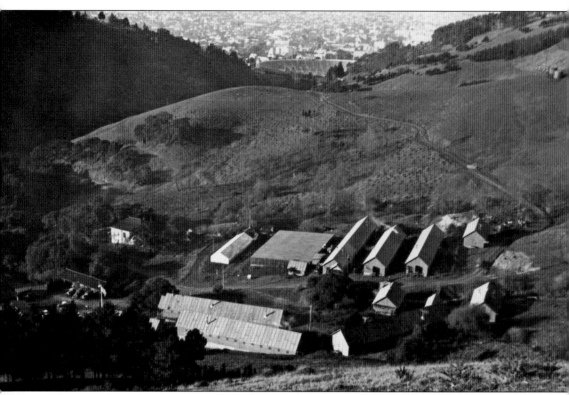

This view faces San Francisco Bay. The Strawberry Canyon CCC Camp buildings are, from back middle left to right, the greenhouse, lathhouse, CCC mess hall, CCC barracks no. 1, CCC barracks no. 2, and CCC hospital (last small building on the right). The building at lower left is CCC barracks no.3; in front of it, the CCC administration building, and the long building angled toward the smaller buildings in the foreground is CCC barracks no. 4. The middle smaller buildings are, from left to right, CCC showers, CCC latrine, and CCC dryer. The camp was located at the site of the present Botanical Garden parking lot. (Civilian Conservation Corps Collection, Archives Center, National Museum of American History, Smithsonian Institution.)

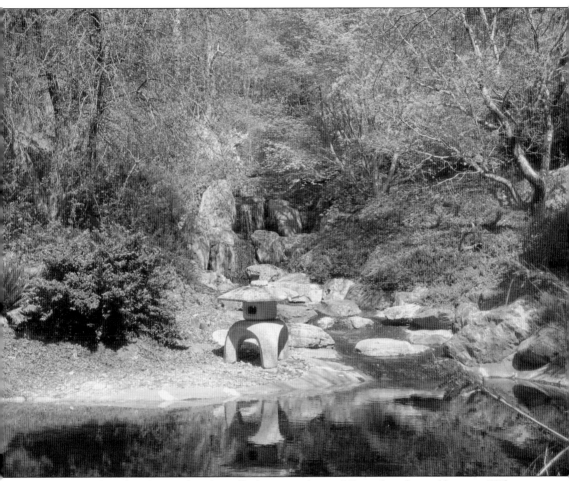

The botanical garden's horticulturalist tells the story of waterfall, pool, rocks, and lantern: "When the Golden Gate International Exposition on Treasure Island closed in 1939, the Japanese exhibit was donated to the garden on behalf of the Japanese government and with the aid of a donation from the UC Japanese Alumni Association. The exhibit was comprised of stone from Japan with lanterns and a bridge displayed as a Japanese garden and pool. Kaneji Domoto, a prominent landscape architect in the Bay Area, assisted in designing the Japanese gardens at the exposition. He also designed the reinterpretation of the display, supervising Japanese workmen as they placed about 150 boulders to create the waterfalls and pool in the garden in 1941." The pool was destroyed in October 1962 when it rained 15 inches in just three days. Boulders and lanterns were swept away by a raging Strawberry Creek. Many of the original boulders were recovered along with one original Yukimi-gata (snow-viewing) lantern. The lantern stands by the pool today; a missing stone ring is a gentle reminder of the October destruction.

Sol Rubin, during a visit to the UC Botanical Garden in 2009, recalled vigorous work improving rails, trimming trees, and clearing brush in the garden during his time at the Strawberry Canyon CCC camp. He also remembered cultivating a love of the outdoors, exercise, and the Bay Area during his nine-month enlistment. CCC "boys" were paid $30 monthly but required to send home $25 to their families, keeping $5 for expenses. (D. Ross Cameron/*Oakland Tribune*.)

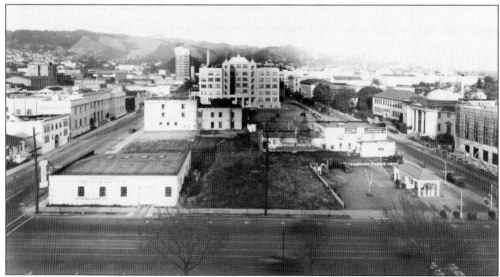

In May 1940, Berkeley voters passed a $125,000 bond measure to acquire property to develop a civic center plaza. This photograph shows that space still occupied by commercial buildings. The new Berkeley High School H Building is under construction in the lower right. Work has not yet begun on the Berkeley Community Theater or buildings demolished for its site. At back is the recently completed Farm Credit Building, and Strawberry Canyon is located in the hills in the background. (BPDHU.)

This is one of the bonds that was issued for the civic center plaza. The first plan for Berkeley's civic center envisioned it as a City Beautiful Movement–style central park area. Architect and city planner Charles Henry Cheney, who drafted California's first city planning act (passed in 1915), provided initial designs for what he called in 1914 Liberty Square. (Steve Finacom.)

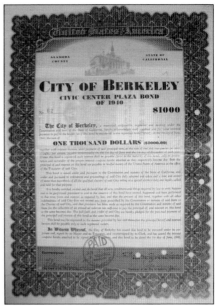

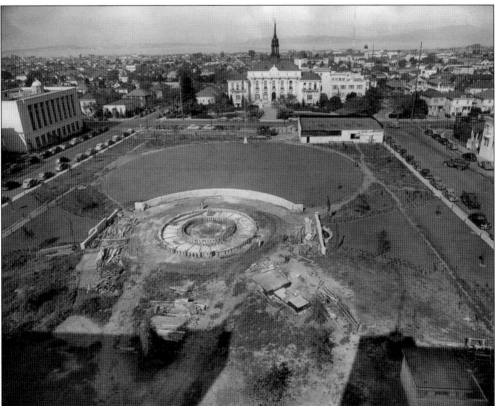

The electrically illuminated fountain set in a flagstone terrace was a gift to the City of Berkeley from the City of San Francisco after the closure of the Golden Gate International Exposition. The city's first playground, located behind city hall west of the civic center, was moved to Civic Center Park in the 1930s when the Hall of Justice was built. (NARA.)

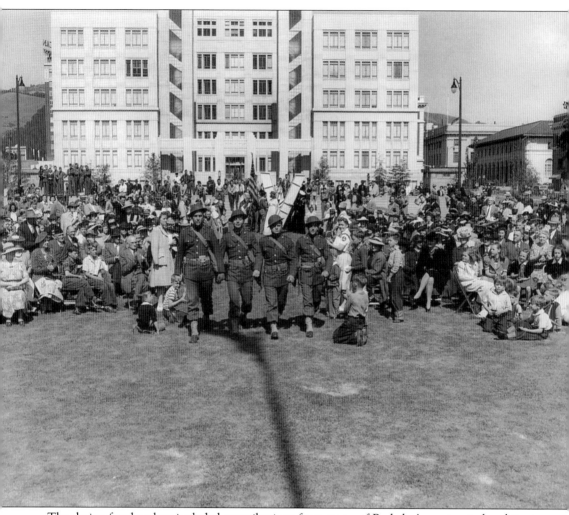

The design for the plaza included contributions from many of Berkeley's most noted architects and landscape architects, and labor was furnished by the federal Work Projects Administration (WPA). Dedication of Civic Center Park took place on Memorial Day 1942. By that time, Berkeley and America had transitioned from the New Deal to the war effort. (NARA.)

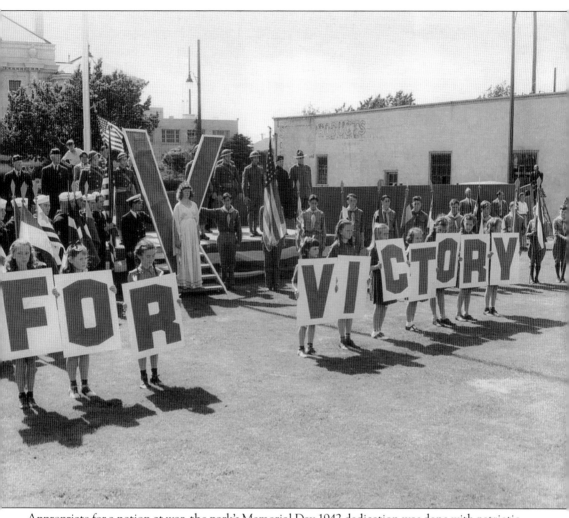

Appropriate for a nation at war, the park's Memorial Day 1942 dedication was done with patriotic pageantry and ceremonies. The building at the right would soon be demolished. (NARA.)

The fountain, no longer flowing, awaits repairs. The large sequoia tree is big and beautiful, but it unfortunately obscures the architectural detail of the civic center building behind it.

The park was designated the Martin Luther King Jr. Civic Center Park in 1983 in honor of the slain civil rights leader. During the years of the anti–Vietnam War movement, the park was also known informally as Provo Park, after the progressive political group of that name, which originated in Amsterdam.

Two

Civic Pride Expressed in Public Buildings

Construction of public buildings during the New Deal continued a tradition of providing citizens with public buildings that expressed democratic values and local civic pride. They were not only built with the need to create functional infrastructure and to provide employment, but with lofty goals in mind. A book summing up the first six years of Public Works Administration (administered by Harold Ickes) construction states, "Perhaps future generations will classify these years as one of the epoch-making periods of advancement in the civilization not only of our own country but also of the human race."

Berkeley's major civic buildings clustered around Civic Center Park, and the New Deal added to this concentration with new buildings, projects, and artwork. They include the Farm Credit Building (now the Civic Center Building), the Berkeley Community Theater, Berkeley High School's G and H Buildings, and the since demolished Hall of Justice. The adjacent Downtown Berkeley Post Office also was adorned with two artworks. Although New Deal buildings were constructed elsewhere in Berkeley, these are the ones that housed functions of local and, in the case of the Farm Credit Building, federal government.

Berkeley's major architect for this period was James W. Plachek, who designed the Farm Credit Administration Building, the Hall of Justice, and many other buildings in Berkeley before and during the New Deal period.

How was this massive nationwide building program paid for? Taxes and deficit spending provided the revenue. New Deal projects generated demand for production materials. Working men and women spent money on necessities and consumer goods, which helped the local economy. They also paid their taxes, which provided more revenue and decreased the deficit. It all seems so logical. Yes, the New Deal created big government through its comprehensive Main Street programs and its regulatory measures. But, it was a practical approach that realized trickle-down economics, tax cuts, decreased spending, deregulation, and privatizing of the public sector does not benefit the average American. This could be summed up by the succinct statement of the famous jurist Oliver Wendell Holmes Jr.: "Taxes are the price we pay for a civilized society."

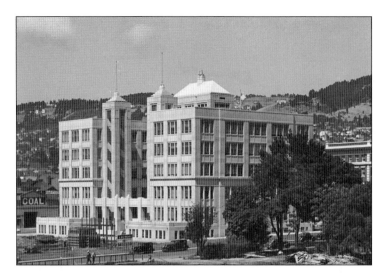

The Farm Credit Building (now the Martin Luther King Jr. Civic Center Building) was designed by architect James W. Plachek and completed in 1940. This side of the building facing Civic Center Park is now largely obscured by a giant sequoia tree. The building in the lower left with the "Coal" sign has since been demolished. (BAHA.)

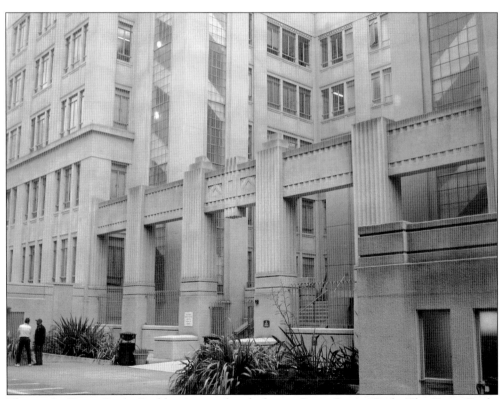

This is the Farm Credit Building's west facade facing Civic Center Park. The Farm Credit Administration was established at the very beginning of the New Deal to extend credit to struggling farmers. Many farmers could not pay off loans, which also led to instability for land banks and farm loan associations. Measures were designed to give farmers emergency loans and to restructure the system of farm credit to save farms.

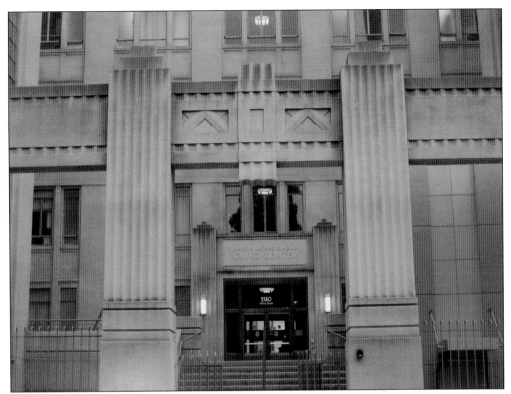

The Farm Credit Building was designed in the Art Deco or WPA Moderne style popular during the 1930s. James W. Plachek also was the architect for the pre–New Deal Downtown Berkeley Public Library. The building housed the Farm Credit Administration and its federal land bank and bank for cooperatives.

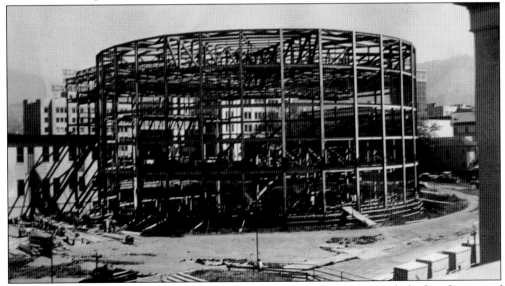

Construction of the Berkeley Community Theater began in 1941 but was halted at the start of World War II. The exposed steel frame was dubbed the "Bird Cage" by Berkeley High students because it became a roost for seagulls waiting for leftovers from student lunches. (BAHA.)

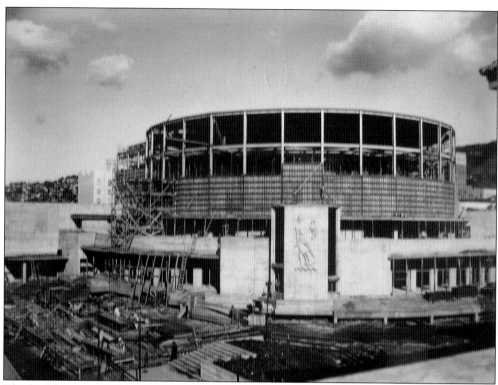

The building was dedicated as a regional performing arts center in 1950 and included the main 3,500-seat auditorium, a 600-seat Little Theater, and facilities for the school music department. (Both, BAHA.)

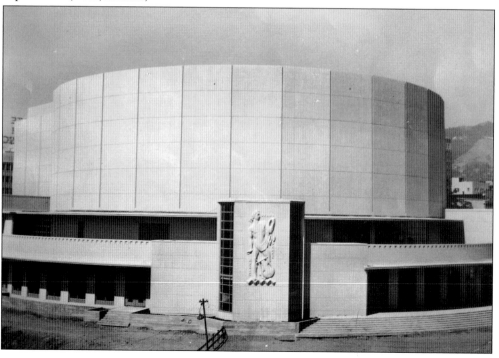

This facade of the community theater faces Civic Center Park. The stairs lead to the entrance of the Florence Schwimley Little Theater, a smaller theater that is often used for Berkeley High School music and theater performances.

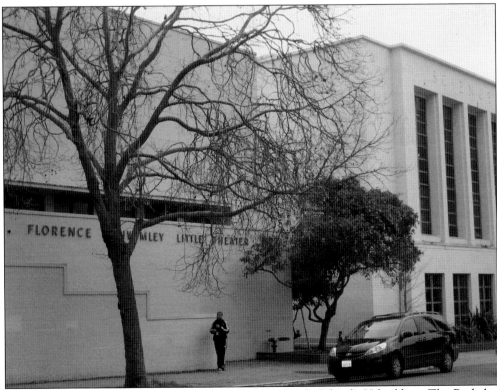

The Little Theater entrance is adjacent to Berkeley High School's H building. The Berkeley Community Theater, Florence Schwimley Little Theater, and the G and H Buildings of Berkeley High School all form part of the Civic Center Historic District, which is listed in the National Register of Historic Places.

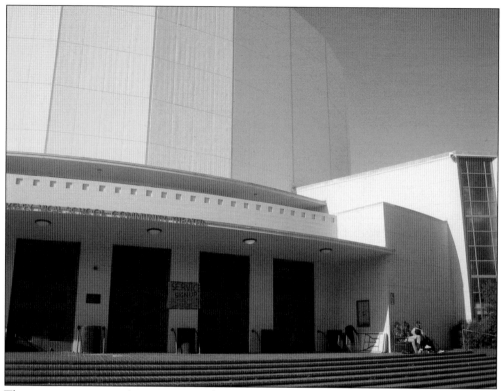

The main entrance to the community theater faces the main courtyard of the high school. It has hosted performances from symphonic to heavy metal, as well as lectures by noted political activists. Performers have included Paul Robeson, Stan Getz, The Grateful Dead, Jimmy Hendrix, Frank Zappa, James Taylor, Richie Havens, The Band, and Cheech and Chong.

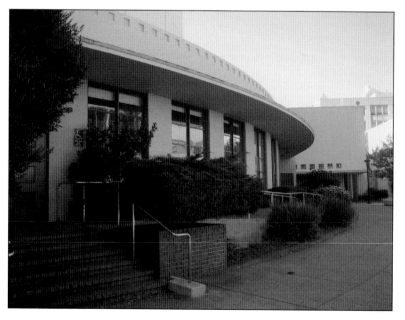

The community theater is formed of many geometric shapes. It was finally dedicated on June 5, 1950, after a nearly nine-year construction delay due to World War II.

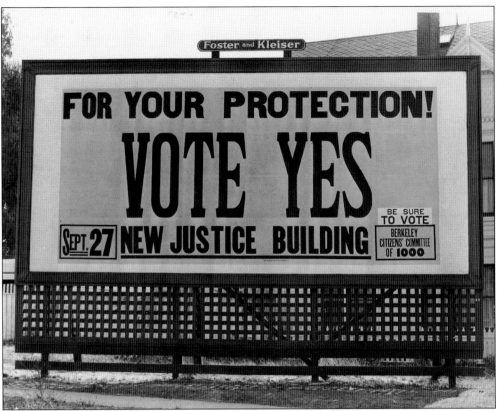

Berkeley voters are urged to vote on September 27, 1938, in favor of a new hall of justice that would house its nationally recognized police department, which pioneered many innovations in law enforcement. Voters passed the bond measure, which would be supplemented by the Public Works Administration (PWA). The city's share of the project was $197,442, and the expected amount from the PWA was $160,000. The PWA required that temporary buildings on the site be demolished by the first week in October, giving urgency to the special election. The measure passed by a vote of 12,821 to 3,397. The drawing below shows a much larger and elaborately finished proposed hall of justice building designed by architect James W. Plachek. Because the completed building would face a residential street, perhaps it was thought that more ornamentation was not needed or funds were less than necessary. (Both, BPDHU.)

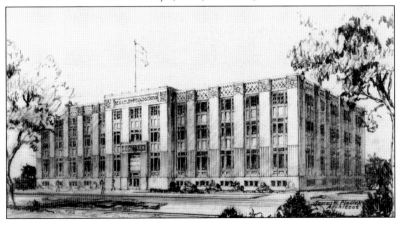

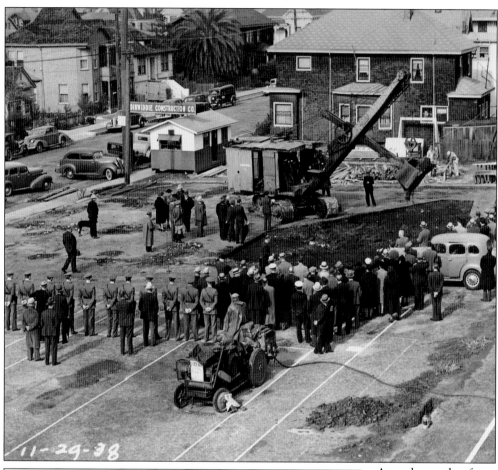

Attendees gather for the November 29, 1938, ground-breaking ceremony for the Hall of Justice. The palm tree across the street is now gone, but the house to the right and the two to the left still stand on McKinley Avenue. (BPDHU.)

Dignitaries, whose fedoras are removed for the photograph, line up for the ground breaking. (BPDHU.)

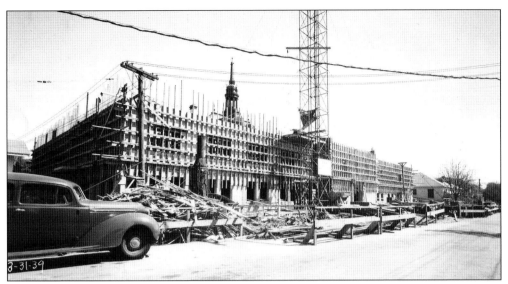

This 1939 photograph of the Hall of Justice building, taken while the building was under construction, shows the concrete forms still in place on the second floor. This view from McKinley Avenue faces east toward the Berkeley Hills and the back side of city hall. The spire of city hall is seen behind the rising structure. (BPDHU.)

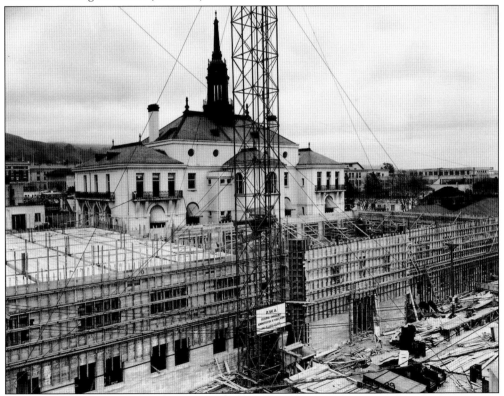

Note the Public Works Administration (PWA) sign on the crane in the bottom-middle of the photograph. The city received $160,000 in a grant from the PWA to construct the building. (BPDHU.)

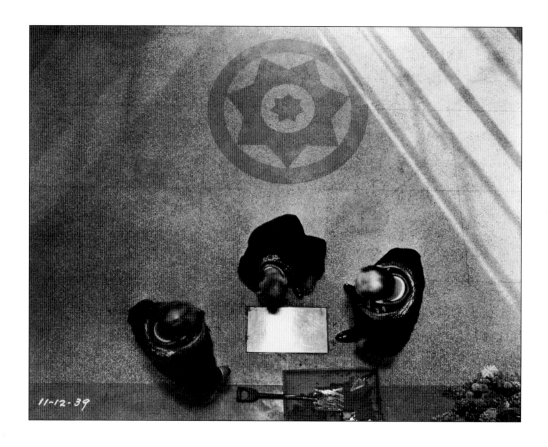

Dedication of the Hall of Justice took place on November 12, 1939. Notice the terrazzo floor with inlay design. Formed in 1875, Native Sons of the Golden West is an organization dedicated to preserving California history. (Both, BPDHU.)

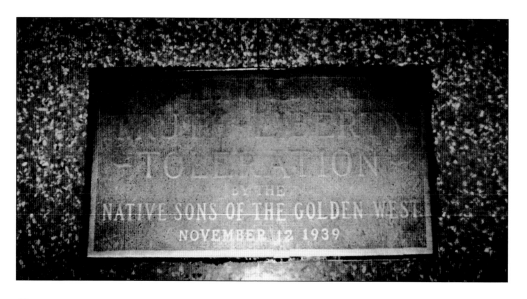

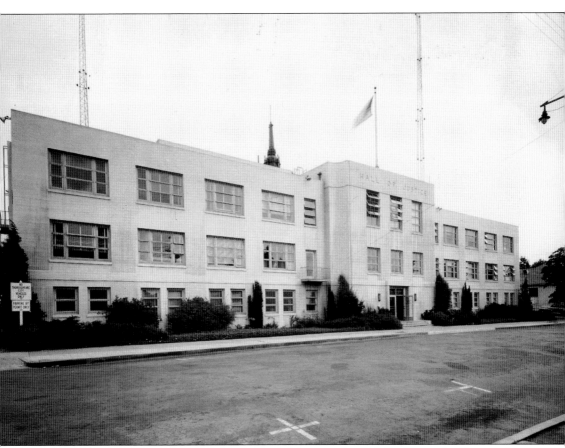

The city hall spire can be seen just above the roof of the completed Hall of Justice building in this August 1948 photograph. In 2002, the Hall of Justice was demolished to make way for a parking lot for the new public safety building. (BPDHU.)

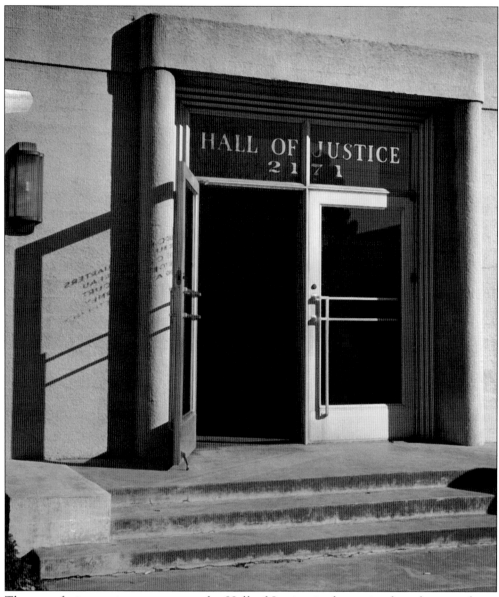

The west-facing main entrance to the Hall of Justice is shown in this photograph—a poignant visual image that memorializes another historic building destroyed and replaced by asphalt. (BPDHU.)

Three

SCHOOLS, LIBRARIES, AND DEMOCRATIC EDUCATION

In a campaign address during his second run for president in 1936, Franklin D. Roosevelt said, "The school is the last expenditure upon which America should be willing to economize." The comprehensive New Deal program for education included new school construction, existing school renovations or additions, support for teacher employment, library construction, nursery schools, CCC education programs, WPA education support programs, adult literacy drives, citizenship education, and worker education. The National Youth Administration hired high school and college youth for work-study and part-time work and provided vocational training and programs for out-of-school youth. Students were given some measure of financial support rather than being burdened with financial debt as they are today.

The largest amount of New Deal aid to education came in the building of schools and libraries. This was particularly the case in California because almost immediately following Franklin Roosevelt's March 1933 inauguration, a major earthquake devastated Long Beach, creating a major need for school construction throughout the state.

Berkeley's Whittier School (now Arts Magnet), the North Branch Library, and the University of California Printing Plant were constructed by the Public Works Administration (PWA). The G and H Buildings at Berkeley High School were built by the WPA, and Lincoln School (now Malcolm X) was improved by the WPA. Teachers were hired, and students were supported through lunch programs or jobs. The WPA also supported a nursery school program. WPA workers did minor improvements on various school buildings. Berkeley school board minutes of August 1939 mention a WPA grant of $237,000 for labor on many Berkeley school building projects. This is in addition to $325,000 that was allocated for constructing the Science and Commerce Building of Berkeley High School. Indirectly, the WPA, National Youth Administration (NYA), and CCC also supported educational efforts.

During the New Deal, relatively few jails and prisons were built. Conscious choices were made—*employment* would be provided, not a *dole* for the unemployed. Workers under various programs were trained to build and renovate infrastructure and to restore the environment. What a contrast to current public policy, which develops elaborate welfare programs and warehouses the down-and-out within the very expensive jail and prison system.

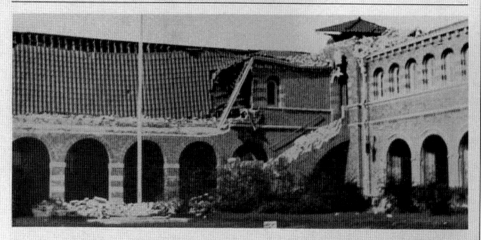

Earthquake Damage—Corrective Measures, School Buildings, *State of California*

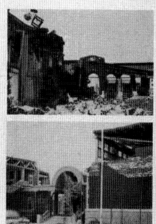

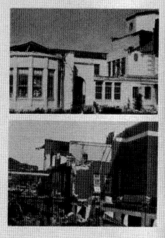

These six illustrations show typical examples of the damage to the school buildings of southern California by the major earthquake which occurred on March 10, 1933. Before this, seismic disturbances had not been given consideration in the design of school buildings. After the 1933 earthquake, the State Legislature enacted a law known as the Field Bill, requiring the State Division of Architecture to regulate, inspect, and supervise the construction, reconstruction, alteration, or addition to all public buildings in California, which, of course, included schools. Every structure is now required to withstand horizontal forces equal to one-tenth of its gravity factor and all the new schools constructed with P. W. A. aid conform to this wise regulation.

182

This page from a 1939 survey of PWA building projects, *Public Buildings* by C.W. Short and R. Stanley-Brown, gives a sense of the earthquake devastation in California and the massive rebuilding effort that would follow with federal support. None of schools pictured are in Berkeley, but the damage created a sense of statewide urgency.

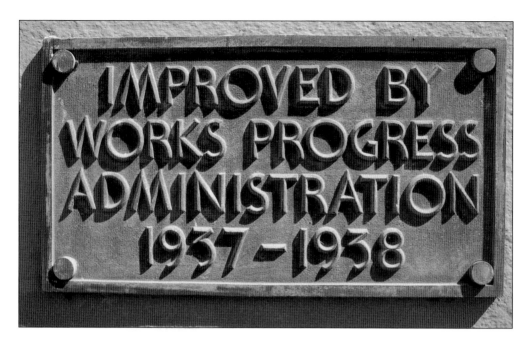

This WPA plaque commemorates the improvements at Lincoln School (now Malcolm X School). Research has not yet revealed what improvements were made, but earthquake safety was undoubtedly on the minds of school administrators.

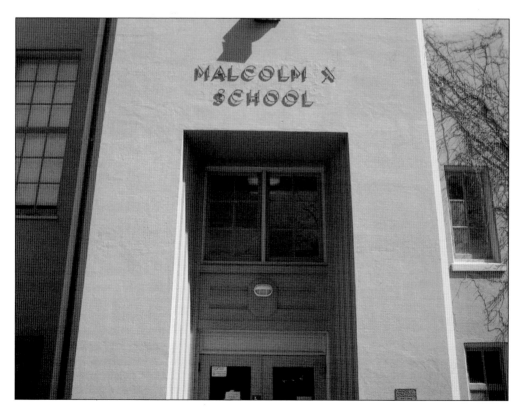

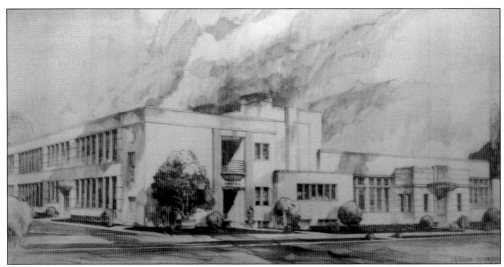

This design was executed for Whittier School by Dragon, Schmidts, Hardman and Officer, Associated Architects. The school was completed in 1939 in classic PWA Moderne style. One-fifth of the $226,000 building cost came from the Public Works Administration. (BPL.)

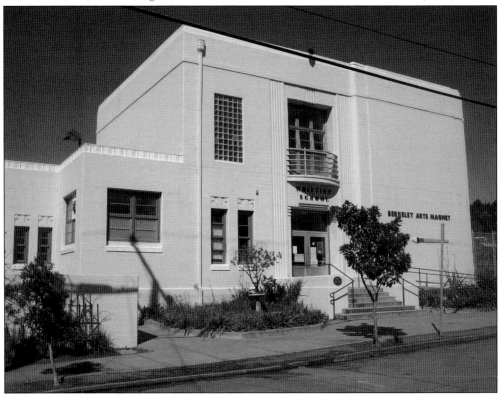

The interior of the school now known as Berkeley Arts Magnet was gutted and remodeled in 1994. Note the geometric patterns above the windows and atop the walls. Whittier School was built as the University Elementary School, a demonstrations school for UC Berkeley. It was designed as the most up-to-date educational facility for 500 to 600 students and is a late example of progressive American school architecture in the period between World War I and II.

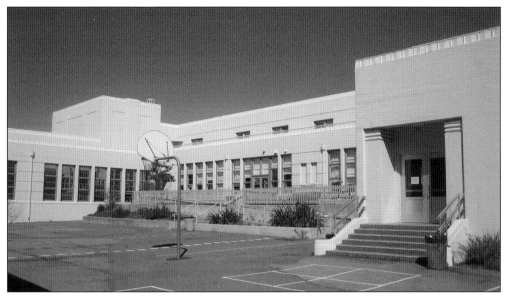

The building is formed of different cube shapes with Art Deco finishes. The many tall windows provide sunlight and fresh air. The scare resulting from the huge March 1933 Long Beach earthquake resulted in children being taken out of school buildings and put in tents. Berkeley saw the need to build a modern fire-resistant, earthquake-proof structure.

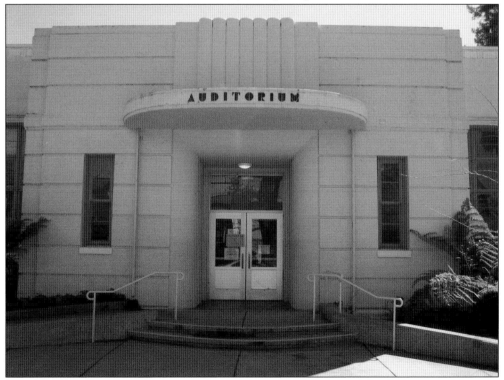

Curved shapes accent this entrance. The auditorium was the site of the dedication of the new school on March 28, 1939. The school would contain 13 classrooms, auditorium, cafeteria, library, and auxiliary rooms.

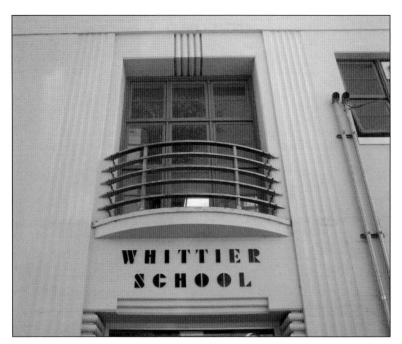

A curved balcony and fluted detailing show off the plasticity of concrete as a building material. Concrete was a favorite material of New Deal construction.

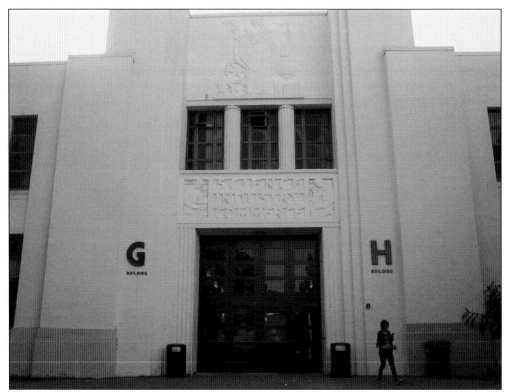

The G (shop) and H (science) Buildings of Berkeley High were designed by architects William H. Gutterson and William Corlett Sr. with support of the WPA. This facade faces the school's interior courtyard.

This facade of the H Building faces Martin Luther King Jr. Way. Reliefs celebrate the industrial arts. In 1995, both the G and H Buildings were retrofitted and the interiors entirely renovated.

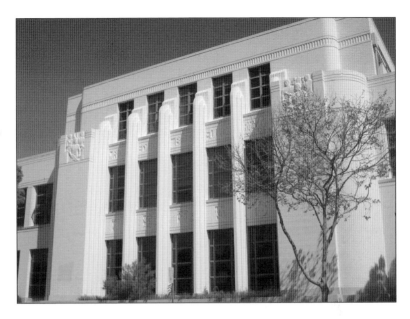

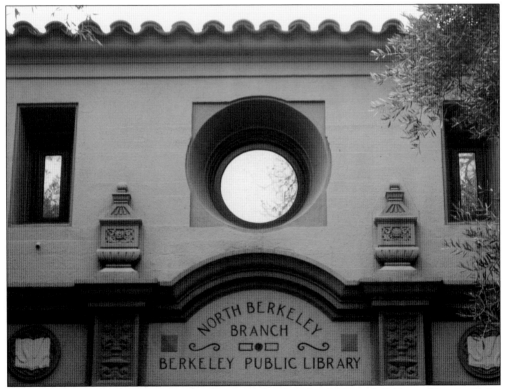

James W. Plachek was the architect of record for the North Branch Library. However, the work was done by a young architect in his office, Frank Thompson, who was told to design a Mediterranean-style building. He did so in grand fashion. Pictured here is the upper portion of the facade, directly above the main entrance.

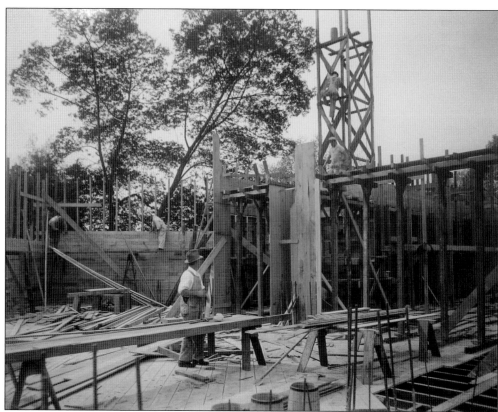

Completed in 1936, the North Branch Library sits on a site filling part of a triangular-shaped block, leaving an open grassy area at its tip. Total cost was $45,236; federal funds furnished $16,167 and the city $29,069. Most of the city funds came from the Library Building Fund raised by a special tax voted by the people for library improvement—part of a long history of Berkeley support for libraries. (Both, BPL .)

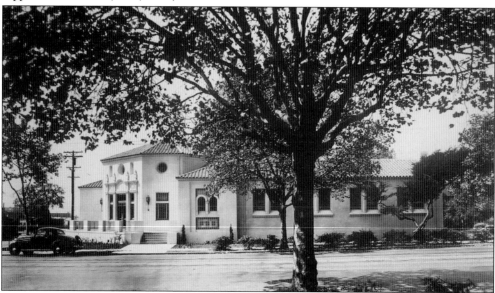

The original building was designed with two wings radiating off its central lobby area, an Adult Reading Room and a Juvenile Reading Room. Due to lack of funds, a back section of the structure, the Club Room, was not built. It was finally constructed during the recently completed renovation and expansion. Pictured is the central lobby area. (James W. Plachek Collection, Berkeley Architectural Heritage Association.)

Ornately designed sheet metal, wrought iron, and leaded-glass light fixtures grace both sides of the main entrance to the library.

The ornately painting ceiling of the main central hall of the library is seen without the original chandelier. A replica replaced it during the recent restoration.

The painted beams and turned support posts of the children's and adult reading rooms give an additional flourish to the building. The lavish architectural detail in some New Deal buildings relied on the talented craftspeople whose trades were threatened by the Depression.

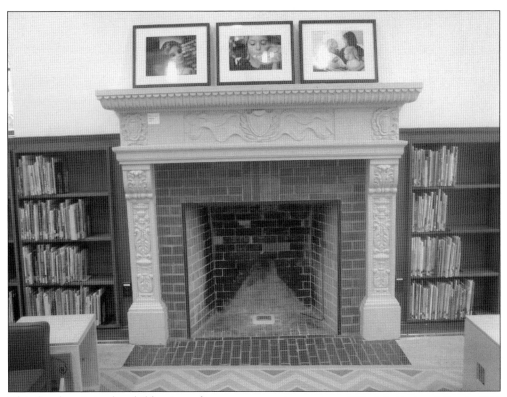

This fireplace is in the children's reading room; the adult reading room also has one.

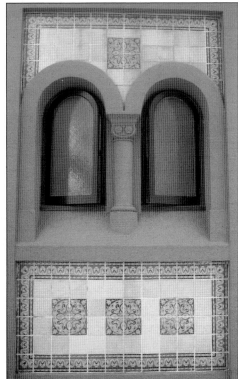

These colorful tile insets with intricate designs offset the arched and ornamented window frames that flank the main entrance.

Windows of the adult reading room face the street in one of the two wings of the original building. The recent renovation involved public meetings to seek citizen input on design options. Architects had proposed an addition that was significantly differentiated from the original structure. Community pressure resulted in a more respectful and compatible design for the new addition.

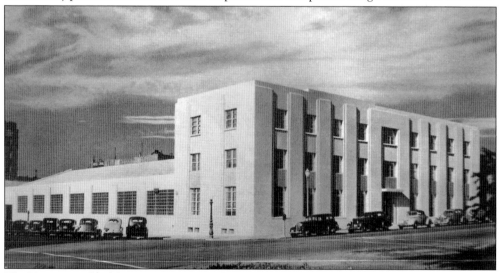

The University of California Printing Plant building is pictured in 1940, the first year it was opened. It is located across the street from the UC Berkeley campus. The building was designed in PWA Moderne style by San Francisco–based Masten & Hurd and completed in 1939 with $146,220 in support from the PWA. The rest of the total cost of $250,000 was paid by the university.

The plant printed books and monographs by university faculty. Toward the end of World War II, the original signatory copies of the Charter of the United Nations and the Statute of the International Court of Justice for the UN conference in San Francisco in 1945 were printed in the building. (UC Berkeley.)

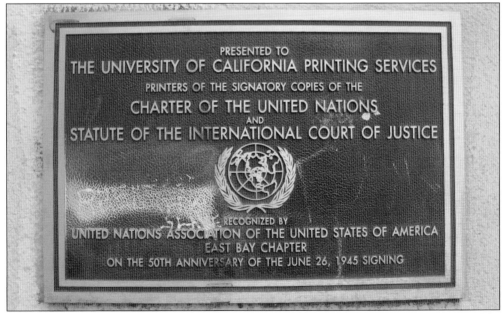

This plaque commemorates the printing of the original United Nations documents. In 1945, fifty nations assembled in San Francisco from April 25, 1945, to June 26, 1945, at the War Memorial Opera House. Next door, in the Herbst Theatre of the Veterans Building, the United Nations Charter was signed. The name United Nations was coined by Franklin D. Roosevelt.

The UC Printing Plant administrative offices and printing plant had been vacant for some years but are now being repurposed to house the university's new Berkeley Art Museum and Pacific Film Archive. The building was divided between the offices of UC Press on the second floor and the UC Printing Department on the first floor and in the printing plant area. The third floor was also used by the Printing Department. The printing plant wing of the building occupied the most space of the building's footprint. It had large north-facing sawtooth windows which allowed abundant natural light onto the shop floor. It remains to be seen if the lobby's simple Art Deco design will survive the renovation for the new Berkeley Art Museum/Pacific Film Archive.

Four

ART FOR THE MASSES

When asked why the government should provide jobs to unemployed artists, the WPA administrator famously replied, "Hell, they got to eat just like other people." Although the Bay Area's artistic center was in San Francisco's North Beach, Berkeley had its share of active artists in the 1930s. With government support, both new and old public buildings were adorned inside and out by local artists. Most of the work in Berkeley was done under two of the four major New Deal art programs, the WPA and the Treasury Relief Art Project. Photography was supported primarily through the Farm Security Administration (FSA) and the NYA.

Over 1,000 US post offices were embellished by New Deal artists, and Pres. Franklin Delano Roosevelt emphasized that "art in America has always belonged to the people and has never been the property of an academy or a class. The great Treasury projects, through which our public buildings are being decorated, are an excellent example of this tradition." Berkeley received two representative examples in its downtown post office. Suzanne Scheuer's mural is typical of the American Scene genre that depicts local history. David Slivka's bas-relief celebrates working people, specifically postal workers.

Among Berkeley's unique artwork is the tile mosaic on the UC campus. Designed by two women, Florence Alston Swift and Helen Bruton, it fits beautifully with the classical historic building it adorns. The community theater, Little Theater, and the G and H Buildings of Berkeley High School were designed to be embellished with the artwork of three different artists. The exceptional work of African American artist Sargent Johnson was a very special contribution at the School for the Blind campus. Easel artists were also employed by the WPA, and the Berkeley Public Library received a collection of 25 prints, which were to be displayed for the enjoyment of library patrons.

Finally, New Deal photography projects had a special link to Berkeley through resident Dorothea Lange and her assistant Rondal Partridge. Lange's images, of course, have become the most iconic of the era and make a major contribution to the general public's visual landscape of the Depression era.

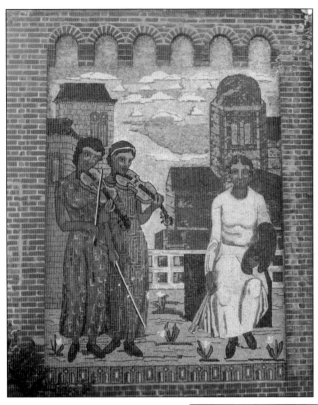

The left side panel of the UC Berkeley mosaic was done by Florence Alston Swift and commemorates music and painting. The structure originally housed the old powerhouse and is located just east of Sather Gate, near Strawberry Creek. The building is currently being considered as a rehearsal and performance space for the university's Department of Music.

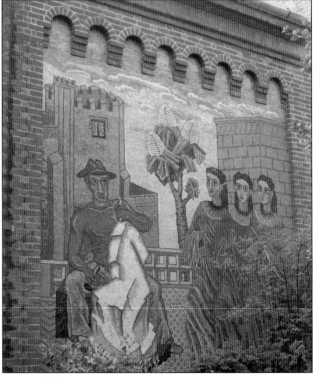

Helen Bruton's panel on the right side celebrates sculpture and the dramatic arts. When the demand for power grew by the end of the 1920s, a new power plant was erected. The building then served as the university's art gallery from 1934 to 1970, when the Berkeley Art Museum was opened. Now, a new museum is being built within the PWA UC Press building.

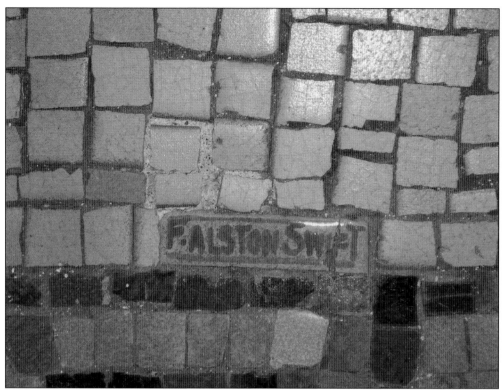

Florence Alston Swift signed her work in the tile above. The mosaics were installed two years after the art gallery opened in 1934. The Romanesque brick structure was one of the earliest Berkeley projects of famed campus architect John Galen Howard, who designed it in 1904 to be the campus's first powerhouse. Below, Helen Burton signed her half of the work. She was one of three sisters, all of whom were artists. She states in her 1964 oral history, "I think so many young artists were so thrilled at the opportunity to just get their teeth into a real project, you know, that they were very earnest and very sincere about it. I feel sure most of them were. There may have been some boondogglers, but I feel that by far the greater proportion were enthusiastic over the opportunity that it gave them."

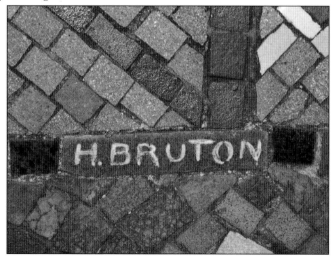

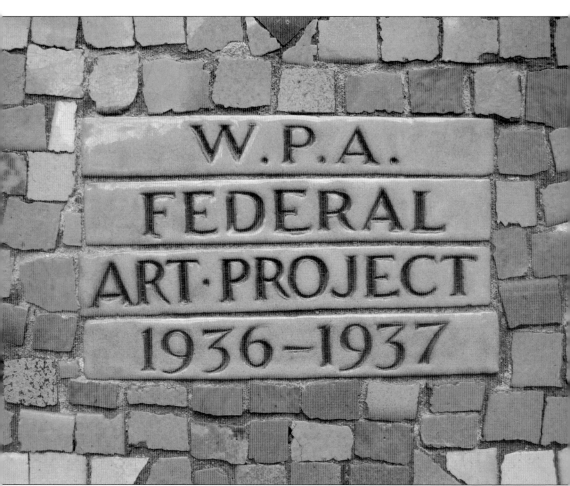

This is one of the few original plaques commemorating Berkeley New Deal projects. However, it is the most unique. The WPA mostly used bronze plaques affixed to project sites, but this was not done universally. Plaques for PWA work are also not very common. This adds to the lack of historic memory of the contributions of the New Deal.

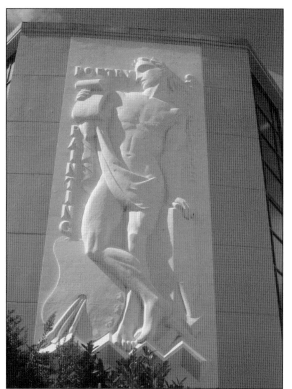

Huge bas-relief sculptures representing the arts adorn the facade facing the interior courtyard of Berkeley High School's Community Theater. Robertt Boardman Howard commemorated poetry, painting, and sculpture in the panel at right. Below, he sculpted an athletic male figure framed by the words *drama, music,* and *dance.*

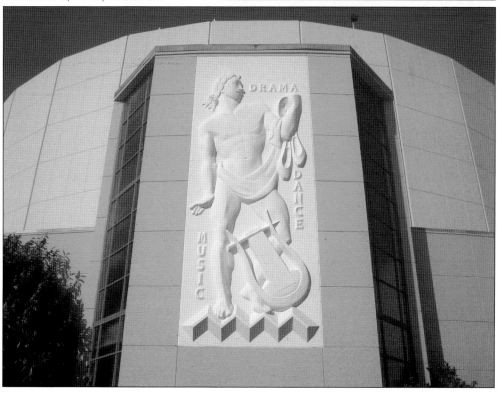

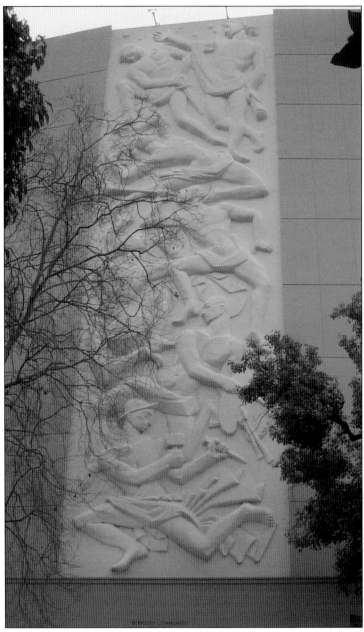

A graduate of Berkeley High School and son of UC Berkeley campus architect John Galen Howard, Robert Boardman Howard created the several-stories-high bas-relief on the facade facing Civic Center Park. Drama is actively portrayed at the top of the panel. A sculptor with African features is portrayed at the bottom of the panel. Some New Deal art of the American Scene genre shied away from political topics. This depiction of multiracial figures within one work was pushing the boundaries of the time. Howard's three brothers were all artists, and one of them was also an architect and assisted in the design of San Francisco's iconic Coit Tower. The tower's interior was the first New Deal mural project, and Howard's brother John painted the fresco titled *California Industrial Scenes*. Robert Boardman Howard sculpted a phoenix in high relief above the main entrance to the tower.

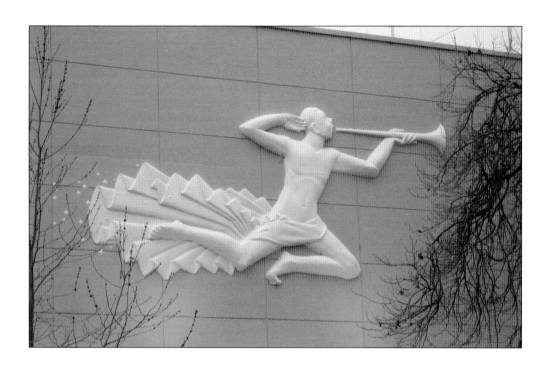

Also done by Howard, the male figure above is one of two heralds flanking the several-stories-high main relief. The female herald below also flanks the huge bas-relief.

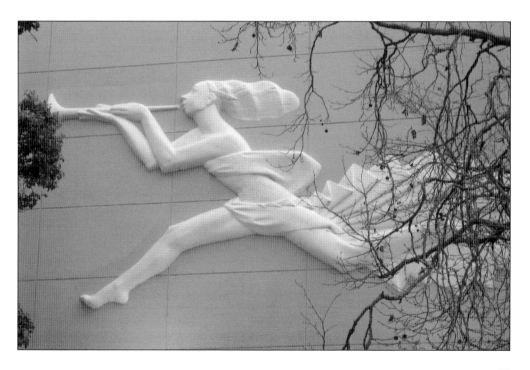

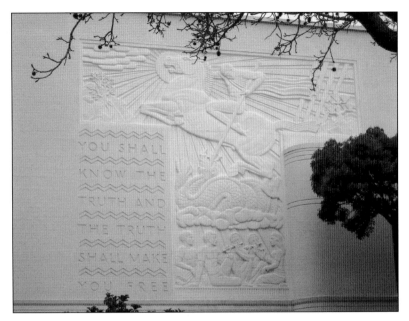

Jacques Schnier portrays the legend of St. George and the Dragon, but his figures on the bottom of the panel have an Asian influence, reflecting his and other artists' work done at the world's fair on Treasure Island in 1939.

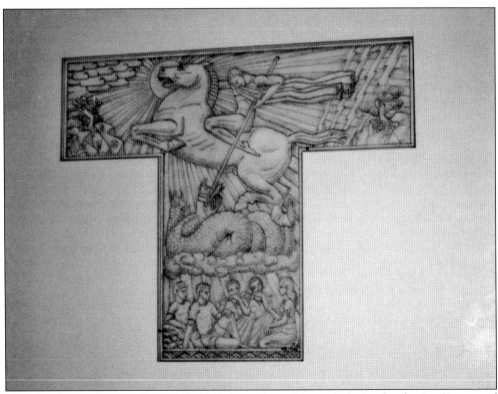

This sketch was done on January 7, 1940, by sculptor Jacques Schnier for the *St. George and the Dragon* relief that was to be executed on the corner of the H Building of Berkeley High School. The label on the back of the framed sketch includes the statement "Enlightened, One Conquers Ignorance."

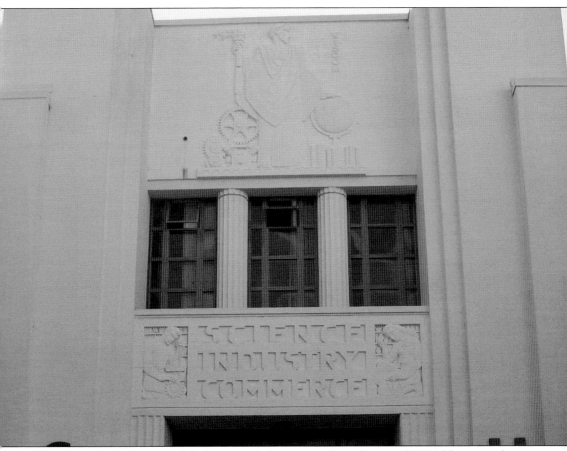

Other than the *St. George and the Dragon* relief, the artwork on the G and H Buildings was done by Lulu Hawkins Braghetta. The imagery in this photograph of the building's facade symbolizes the significance of the learning that takes place there. Wisdom is portrayed in the bas-relief as a robed woman holding a torch in her upraised right hand, while her left hand rests on a globe, which is atop several books. At her right side is some machinery, including an air-cooled engine and gears. Above the entryway is a bas-relief of two figures, one male and one female, flanking the words "Science/Industry/Commerce," which represent the subjects taught in the G and H Buildings. This facade faces the interior courtyard.

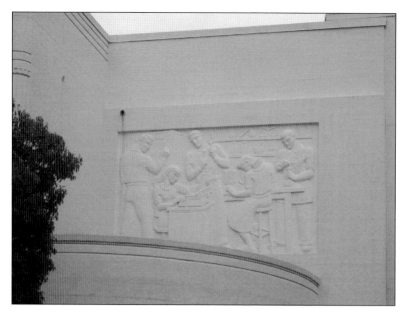

Laboratory work is depicted in physics with a tuning fork, in biology with a microscope, and in chemistry with a beaker and flask. The student with the typewriter is recording the data. This relief flanks the left side entrance on Martin Luther King Jr. Way.

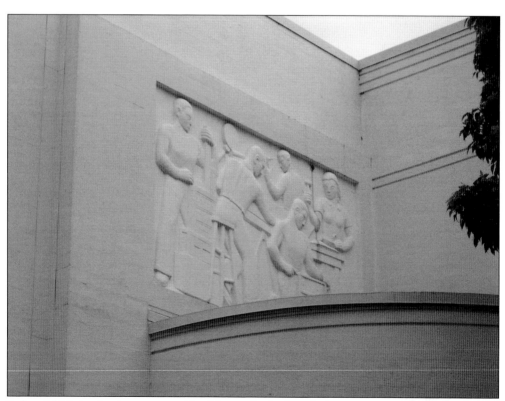

Industrial fabrication is represented in this panel, which includes a woman with a hammer. This relief flanks the right side of the entrance on Martin Luther King Jr. Way and is on the building dedicated to the industrial trades.

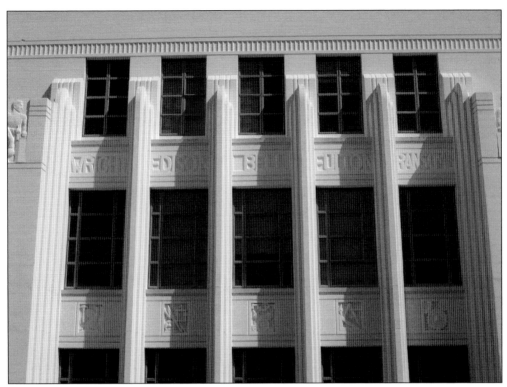

The great inventors are named in these reliefs representing the industrial arts. Wright, Edison, Bell, and Fulton are all well-known names of American inventors. The last name probably refers to Ernest L. Ransome, who invented new techniques for concrete construction. In the photograph below, construction laborers at work are seen at the top of a column flanking the windows of the G Building.

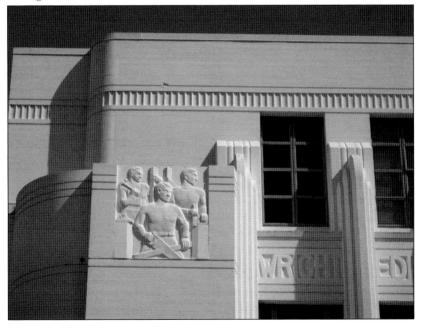

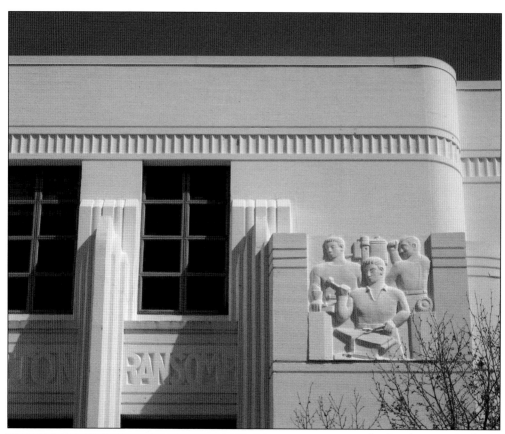

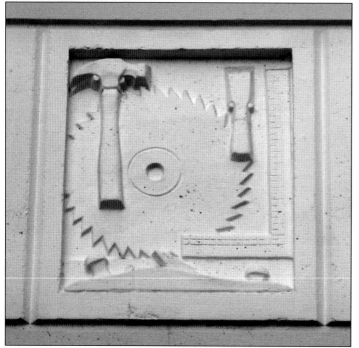

In the photograph above, metalworkers are atop a column at the other side of the windows of the G Building. At left, carpentry is represented by a hammer, a saw blade, a chisel, a square, and a plane in one of five representations of the construction and industrial trades.

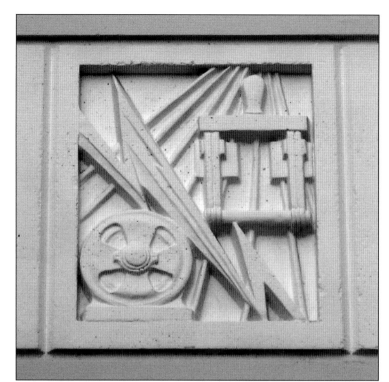

Electrical work is represented by a lightning bolt, rays, a switch, and a generator. Below, motor mechanics is shown with a crankshaft, piston cylinders, a gear, a flywheel, and valve springs.

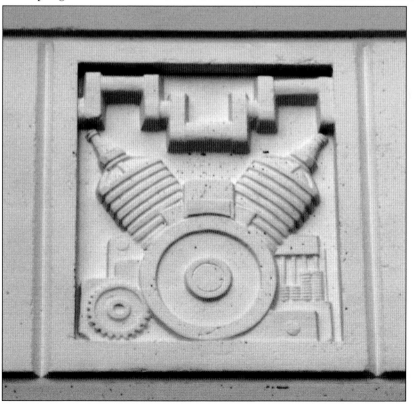

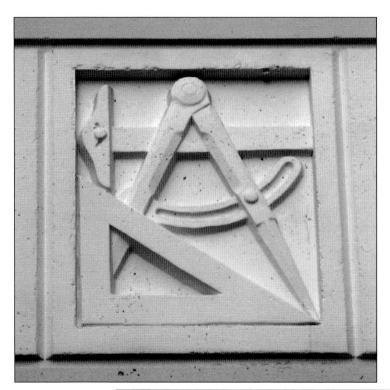

Industrial drawing is symbolized by a T square, a compass, and a tri-square. Machining, in the last of the five below, is represented by the interlocking gears.

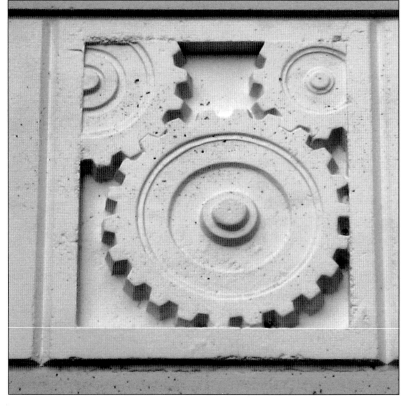

This carved redwood relief by Sargent Johnson for the WPA was a stage curtain in an auditorium of the California School for the Blind and was a companion piece to a pipe-organ screen. When students were moved out from the school because it was not earthquake safe, the site was taken over by UC Berkeley for use as student housing and as a conference center. Unfortunately, this relief is in an upstairs conference room and not very accessible to the general public.

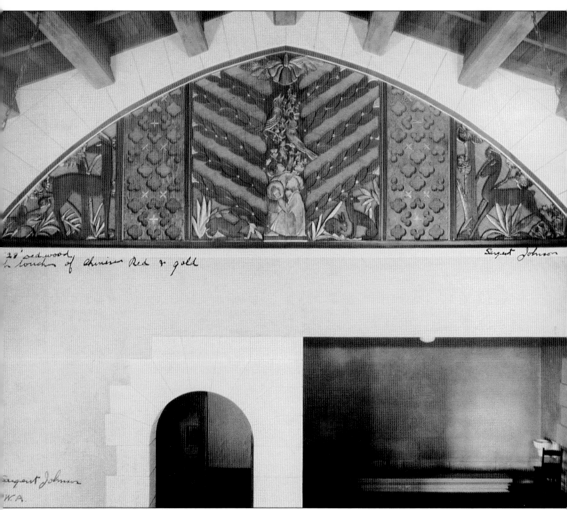

Produced under the WPA, the Sargent Johnson pipe-organ screen is pictured in its original location at the School for the Blind auditorium. Johnson also did a companion carved-redwood pipe-organ screen that was 9 feet high and 22 feet long. When the University of California acquired the old Schools for the Deaf and Blind campuses in the early 1980s, the screen was removed from its building during renovations and ended up forgotten in off-campus storage for years. When it was uncovered in pieces during a cleanup of storage spaces in 2009, UC staff declared the piece surplus. Besides being totally irresponsible, this should have been an illegal act because the public institutions that were given artworks during the New Deal hold them in trust for the American people. However, it was sold to an art dealer for $150 plus tax and eventually made its way to the Huntington museum, where it is now insured for $1 million. (The Harmon Foundation Collection, Still Picture Collection, National Archives, College Park, Maryland.)

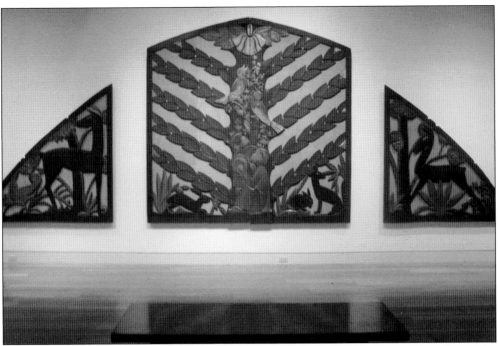

The restored Sargent Johnson pipe-organ screen is pictured at the Huntington. The effect of the artwork has been described as dramatically modern—somewhere between the Zigzag (Art Deco) Moderne of the late 1920s and the Streamline Moderne of the 1930s.

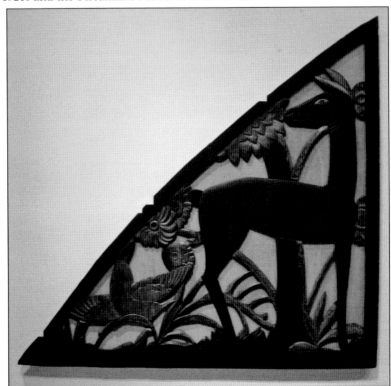

Wonderful but delicate detail is seen in the central and side panels. During the restoration, a scrap of the material that backed the screen was found, and it was matched as closely as possible.

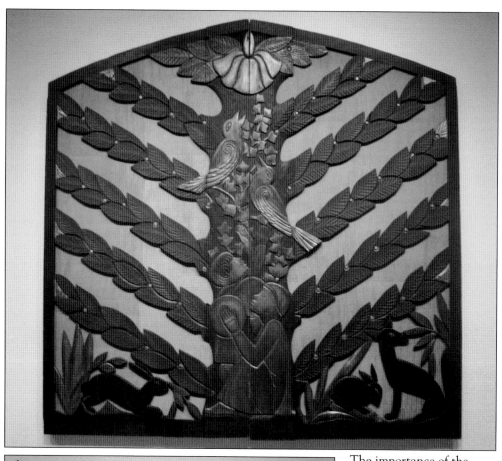

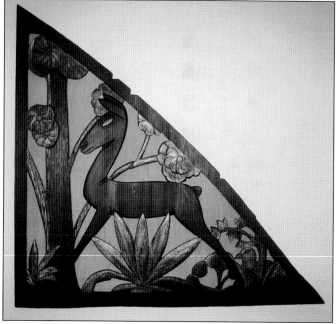

The importance of the sounds of nature and music to blind children is a theme of the central panel. Two narrow panels went between the central and side panels; they have not been found.

Plants and animals in a whimsical forest are portrayed in the central and side panels. Besides doing both delicate wood carving and monumental concrete reliefs, Johnson also did works on paper and ceramic pieces.

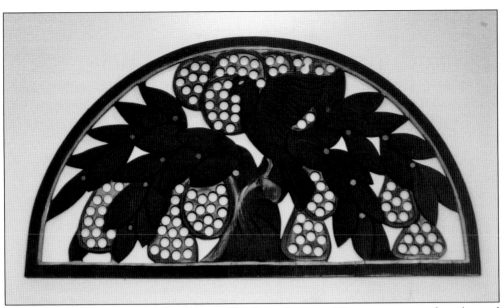

Johnson also carved two window lunettes for the auditorium. These are now at the relocated School for the Blind and Deaf in Fremont.

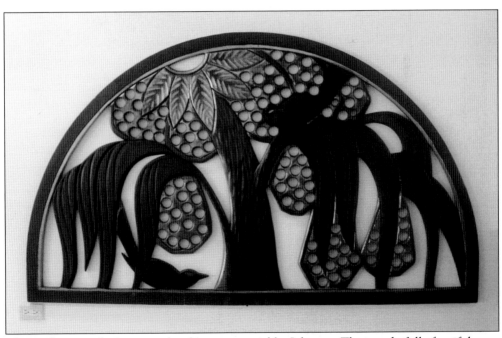

This is the second of two window lunettes carved by Johnson. The wonderfully fanciful trees and birds are seen in these simpler pieces. Johnson also did sculptures for the 1939 San Francisco World's Fair.

The above piece was also completed during Johnson's work at the school, probably as part of his WPA commission. In his 1964 oral history for the Smithsonian Institution, Sargent Johnson states, "It's the best thing that ever happened to me because it gave me more of an incentive to keep on working, where at the time things looked pretty dreary and I thought about getting out of it because, you know, I come from a family of people who thought all artists were drunkards and everything else. I thought I'd given it up at one time but I think the WPA helped me to stay." Below is the limestone relief carved by David Slivka in 1937 for the Treasure Relief Art Project for the portico of the Downtown Berkeley Post Office. Like Johnson, Slivka also did work for the world's fair on Treasure Island.

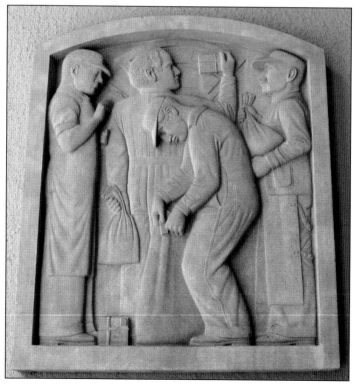

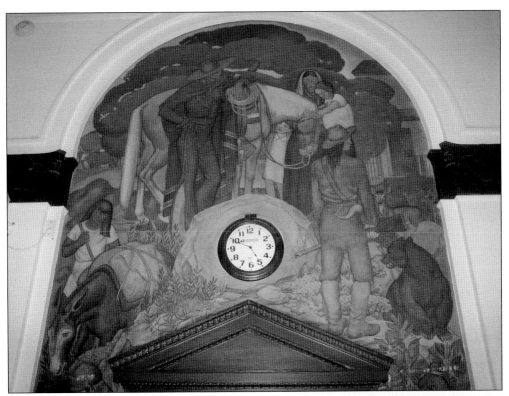

This is the upper portion of the mural painted by Suzanne Scheuer in 1936–1937 under the Treasury Relief Art Project for the interior of the Downtown Berkeley Post Office. Typical of American Scene artwork, it shows the multicultural history of Berkeley from the initial Native American inhabitants to the Californios after independence from Spain to the mountain men of the American frontier to the settlers and squatters on Mexican land.

The Spanish soldier represents the early invasion by the Mexicans of Spanish descent. Horses were introduced to California by the Spanish. Scheuer was one of the Coit Tower muralists and painted the section on the newspaper industry. She also painted two post office murals in Texas.

The father represents the Spanish padres that established the California mission system. He holds a list of dates important in Berkeley's early history.

Scheuer places Berkeley of the 1930s within the context of its early history. The Downtown Berkeley Post Office is, at this writing, under threat of being sold. How ironic that the New Deal created public buildings and art, and the current political initiative is to privatize public buildings and the art that was paid for by taxpayers.

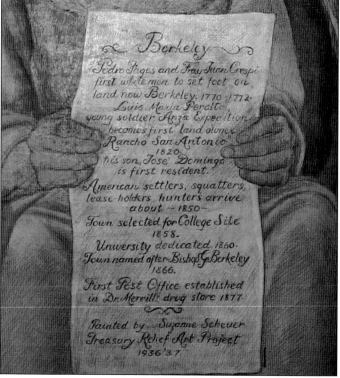

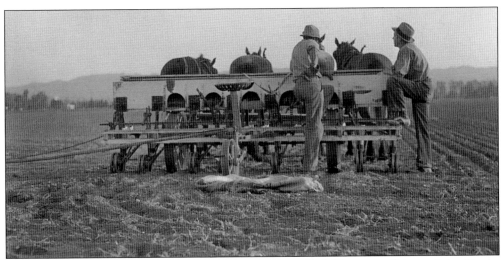

Dorothea Lange, a longtime Berkeley resident, photographed "Farmers talking politics. Potato fields. California" in February 1936. More than just portraying destitute Dust Bowl refugees, Lange gives a sense that these people also had their opinions and their sense of place in the crisis of the 1930s. Lange's photograph of the "Migrant Mother" has become an icon of the Great Depression era. (FSA/OWI.)

Tom Collins managed federal migrant camps in the Central Valley and was John Steinbeck's informant and friend. Collins also contributed the songs of migratory farm laborers that he collected to the California Folk Music Project. Lange's caption describes this scene: "Tom Collins, manager of Kern migrant camp, California." (FSA/OWI.)

Dorothea Lange is known for her California migrant photographs, but she also traveled to other parts of the country for the FSA. This Lange photograph is captioned "Cotton worker in Sunday clothes. Near Blytheville, Arkansas" and was taken in June 1937. John Steinbeck depended on the work of Lange and other FSA photographers for his visual picture of the Dust Bowl states; he had never spent time in Oklahoma before writing *The Grapes of Wrath*. (FSA/OWI.)

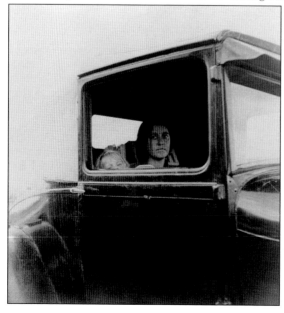

Lange's caption reads, "During the cotton strike the father, a striking picker, has left his wife and child in the car while he applies to the Farm Security Administration for an emergency food grant. Shafter, California." The photograph was taken in November 1938. (FSA/OWI.)

This gas station's message alludes to a basic sentiment during the period of the New Deal. What a wonderful admonition for the 1930s (or for today)! Lange simply captioned this image from November 1938 "Gas station. Kern County, California." (FSA/OWI.)

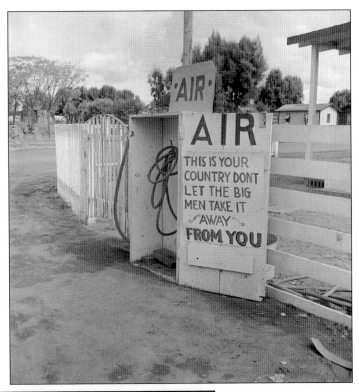

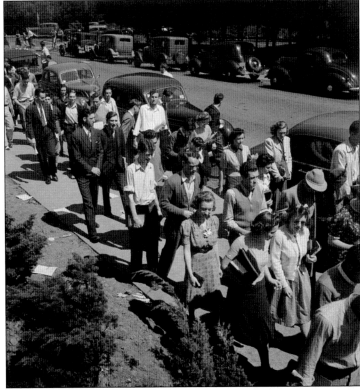

Lange's caption for this image taken at UC Berkeley in April 1939 reads, "Students assembling for Peace Day address of General Smedley Butler." After a 34-year career, Butler became known for having become an outspoken critic of US wars and exposing a plan to overthrow Pres. Franklin Roosevelt. Butler was a US Marine Corps major general, the highest rank at that time. When he died, he was the most decorated marine in US history. (FSA/OWI.)

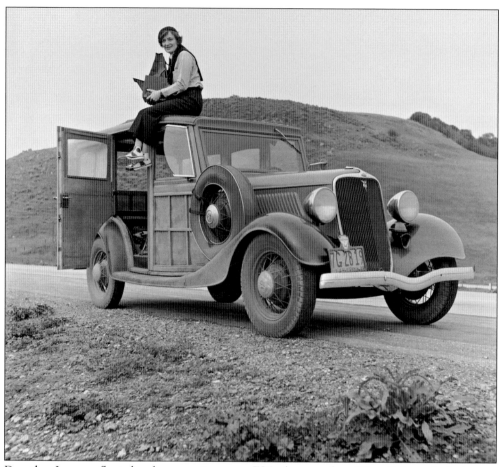

Dorothea Lange reflected on her experience as a FSA photographer: "Now if they asked who you were, and they heard you were a representative of the government, who was interested in their difficulties, or in their condition, it's a very different thing from going in and saying, 'I'm working for *Look* magazine, who wants to take pictures of you.' It's a very different thing." (Photograph by Rondal Partridge/Library of Congress.)

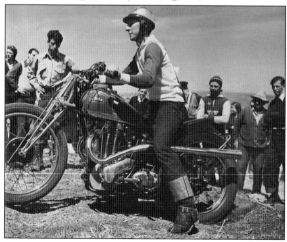

The National Youth Administration (NYA) hired high school and college youth for work-study and part-time work and provided vocational training and programs for out-of-school youth. Rondal Partridge was hired to do his "Study of Youth" photographs in 1940. He had previously been Dorothea Lange's assistant. Ron's description for this photograph is "Santa Clara County, California. Motorcycle and Hill Climb Recreation. April 5, 1940." (© 1940, 2014 Rondal Partridge Archives.)

Ron described this young woman as a "migrant youth in potato field. This is a characteristic costume of women in the potato fields. This girl came from Oklahoma, but has lived in Kern County long enough to be considered a resident, April 9, 1940." (© 1940, 2014 Rondal Partridge Archives.)

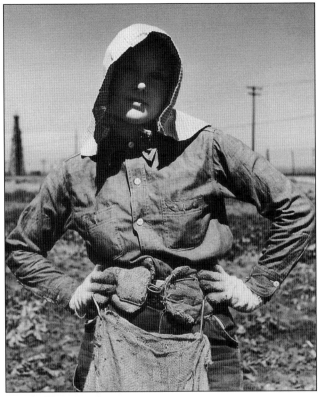

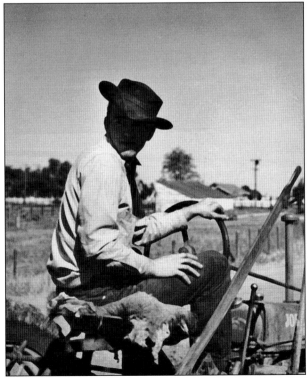

Ron described this young man as "a local Salinas Valley youth, skilled in mechanical operation. Graduated from high school in January 1940, he has been steadily employed ever since as a tractor operator . . . and several farms bid for his services. May 2, 1940." (© 1940, 2014 Rondal Partridge Archives.)

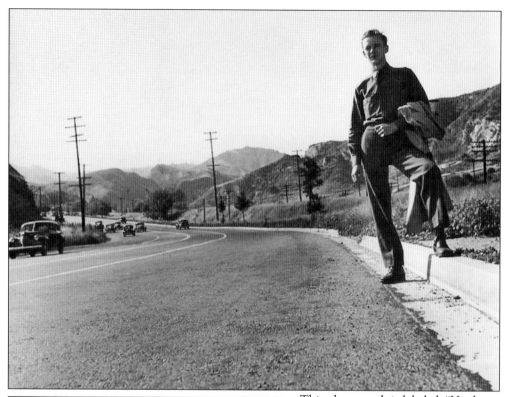

This photograph is labeled, "Hitch-hiking. This Civilian Conservation Corps boy is returning to camp about thirty miles away after a weekend visit to his family in Los Angeles. San Fernando. April 28, 1940." While it was popular again in the 1960s and 1970s, it is rare to see a hitchhiker in Berkeley today. (© 1940, 2014 Rondal Partridge Archives.)

Partridge made the following note for this photograph: "Youth stand in line with oldsters to collect their surplus commodities, San Leandro, May 3, 1940." The youth is holding a burlap sack to carry the commodities. (© 1940, 2014 Rondal Partridge Archives.)

Ron described this photograph: "Hanging Around. Out of high school and unemployed. When the future is insecure, the past has a romantic appeal, San Francisco. May 1940." His documentation of California's youth on the brink of World War II captures those moments in time before everything would change. (© 1940, 2014 Rondal Partridge Archives.)

Rondal Partridge, pictured in his Berkeley home in March 2010, learned photography from his mother, the renowned photographer Imogen Cunningham. In the 1930s, he assisted Ansel Adams and Dorothea Lange, who suggested he work with the National Youth Administration and may helped to get him the 90-day assignment. Later, he worked as a photojournalist and a Navy photographer. After the war, he worked for major magazines, and he has done environmental and architectural photography.

In November 1936, the Berkeley Public Library received 25 prints from the WPA to display for library patrons. The library signed a statement that reads, "Ownership is vested in the United States Government." This lithograph is based on a drawing by Lala Eve Rivol, who got the unique assignment to travel and record Native American rock art. This historical record is invaluable today because the pictographs and petroglyphs later became degraded by weather or vandalism. (BPL.)

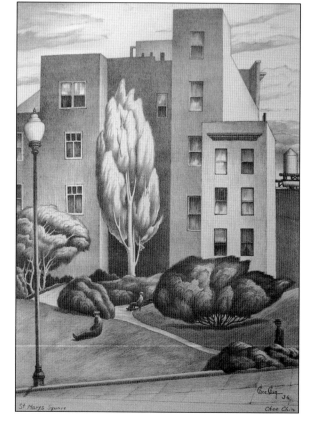

Chee Chin created this view of the park next to San Francisco's Chinatown. In the late 1930s, the library began a lending program so that patrons could check out the WPA prints. The program was successful, with little theft or damage, and other libraries became interested; however, the program was shut down by the federal government since it opposed the directives of the WPA—that the art be used only for "public" display. (BPL.)

This view of the headquarters of the Federal Arts Project in San Francisco is by Marguerite Redman Dorgeloh. She demonstrated lithography by using stones as part of a Federal Art Project booth called Art in Action at the second year of the world's fair on Treasure Island in 1940. (BPL.)

William Hesthal ironically called this print *Afternoon Sun*, perhaps as a commentary on the trash in the empty lot revealed by the glare of day. He was a painter at Coit Tower, and his fresco panel was titled *Railroad and Shipping*. (BPL.)

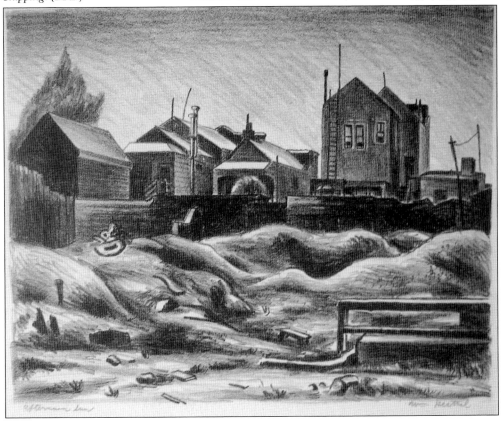

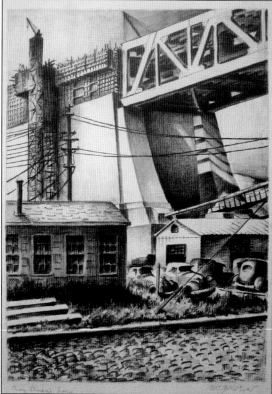

Arthur Murphy was a WPA lithographer who was influenced by the three great Mexican muralists—Rivera, Orozco, and Siqueiros. Like other artists of the period, Murphy also worked in the style of Social Realism, which was an international art movement. Artists of the movement drew attention to the conditions of working and poor people and of the social and political structures that maintained conditions of poverty. (BPL.)

Otis Oldfield's print shows the construction of the San Francisco suspension-cable western anchorage of the Bay Bridge. This is one of a series of prints Oldfield did. The eastern cantilever span was recently replaced by the new single-tower suspension bridge. Oldfield was also a Coit Tower muralist, and he painted three lunettes over doors in the elevator lobby. Two were titled *Seabirds*, and one was titled *Bay Area Map*. (BPL.)

Five

ENTERTAINMENT AND CULTURE

The visual arts were only one of the WPA Federal Art Project's divisions. Others included theater, writing, and music. Hallie Flanagan, director of the Federal Theatre, sums up the direction of the arts projects in her introduction to the book *Federal Theatre Plays* in 1938:

> Being a part of a great nationwide work project, our actors are one, not only with the musicians playing symphonies in Federal orchestras; with writers re-creating the American scene; with artists compiling from the rich and almost forgotten past the *Index of American Design*; but they are also one with thousands of men building roads and bridges and sewers; one with doctors and nurses giving clinical aid to a million destitute men, women and children; one with workers carrying traveling libraries into desolate areas; one with scientists studying mosquito control and reforestation and swamp drainage and soil erosion.
>
> What has all this to do with theatre? It has everything to do with the Federal Theatre. For these activities represent a new frontier in America, a frontier against disease, dirt, poverty, illiteracy, unemployment, despair, and at the same time against selfishness, special privilege and social apathy. The struggles along this frontier are not political in any narrow sense. They would exist under any administration. Taken collectively they illustrate what William James meant when he talked about a moral equivalent for war.

The Federal Writers' Project hired not only recognized writers, but thousands more with minimal writing skills and put them to work to document America with guidebooks and interviews. In the brief period from 1935 to 1939, project workers in all 48 states researched history and documented local communities. They created travel guides for every state and many cities.

The California Folk Music Project was based in Berkeley from 1938 until 1940 and was a joint effort of the Work Projects Administration, the Library of Congress, and the Music Division of the University of California, Berkeley. The project was conceived and directed by Sidney Robertson Cowell and was one of the earliest attempts to document and record ethnic folk music in the United States.

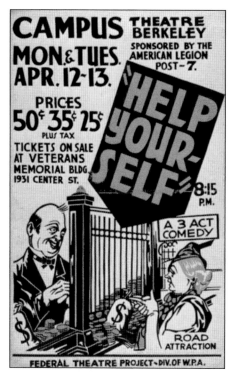

Hallie Flanagan, director of the Federal Theatre Project, described *Help Yourself* by Paul Vulpius as creating "comedy from its situation of the unemployed young man brightly hanging up his hat in a bank where he had no job and becoming the leading expert in a land deal that never existed in fact." The Campus Theatre was located at 2440 Bancroft Way. (George Mason University Libraries.)

Toby Cole was a Federal Theatre Project actress in New York, and when *The Cradle Will Rock* cast and audience were locked out of its original venue, she participated in the march to another theater so the show could go on. Later, as a theater and literary agent, she helped to resurrect the careers of artists blacklisted in the McCarthy era. She was a Berkeley resident for many years until her death.

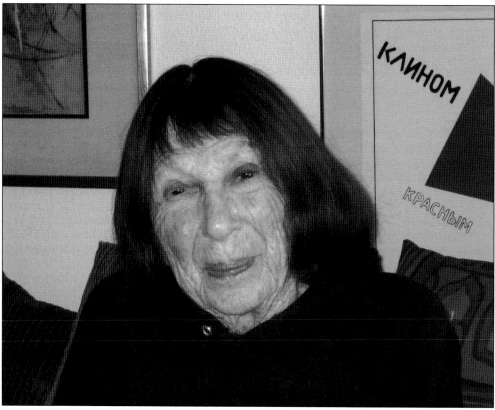

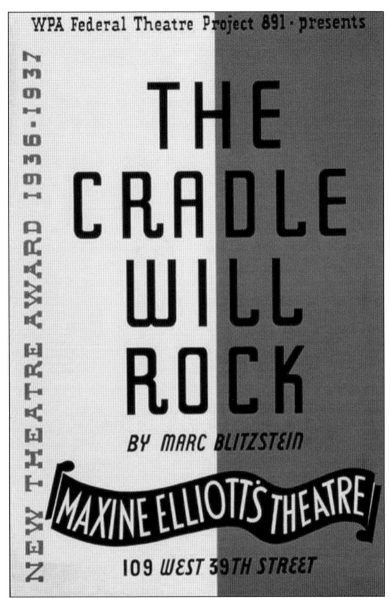

This is the poster for the originally scheduled performance that was displaced by the lockout. The 1999 Tim Robbins film *Cradle Will Rock* portrays this episode and the beginnings and termination of the theater project. Hallie Flanagan had hoped that the federal theater might lay the groundwork for developing a national theater, as was commonplace in many countries. This poster was produced by the WPA Federal Art Project NYC, as seen in the lower right corner. Thousands of posters were produced from 1936 to 1943 by various branches of the WPA. Of the 2,000 WPA posters known to exist, the Library of Congress collection of more than 900 is the largest. The posters were designed to publicize exhibits, community activities, theatrical productions, and health and educational programs in 17 states and the District of Columbia. Artist Anthony Velonis introduced the silkscreen process to the WPA poster division in New York City, enabling this art form to be produced cheaply and distributed widely. Artists were able to explore different styles in their efforts to reach a mass audience. (George Mason University Libraries.)

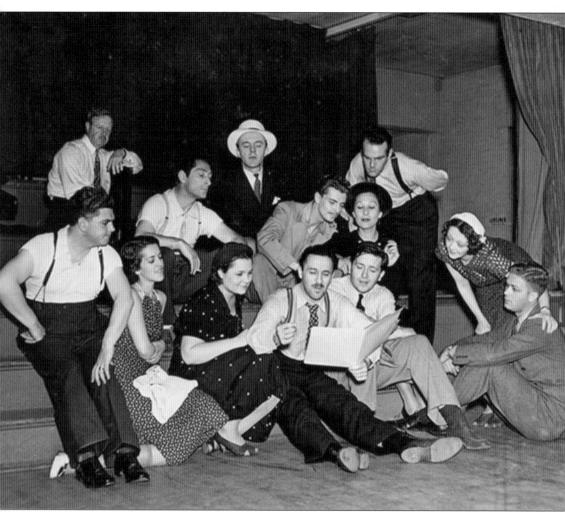

The Cradle Will Rock was directed by Orson Welles and produced by John Houseman. When the WPA shut down the production a few days before opening, the cast and audience marched uptown from the Maxine Elliot to the Venice Theatre. To avoid government and union restrictions, the show was performed with Blitzstein playing piano onstage and the cast singing from the audience. It was a huge success with the theater going public. However, the work of the Theatre Project drew criticism from Congress. One of its programs, the Living Newspaper productions, performed plays on current events and politically themed events. (The San Francisco Mime Troupe is a contemporary version.) Another unit was devoted to African American plays and employed black playwrights, directors, actors, and technicians. The newly formed House Committee on Un-American Activities shifted its focus from investigating the Ku Klux Klan to a probe of the WPA. Eventually, both the Theatre Project and Writers' Project lost Congressional support. The committee went on to support the Japanese American internment and to investigate Hollywood, which led to the industry blacklist. (Federal Theatre Project Collection, Music Division, Library of Congress.)

Ruth Acty tells her story in this newspaper article. She was an actress with the Federal Theatre Project (FTP) in San Francisco and one of the stars in *Run Little Chillun*, which opened on January 26, 1939, with an all-black cast of 150. A big hit the previous season with the FTP in Los Angeles, it was also highly successful in San Francisco. Ruth went on to become Berkeley's first African American teacher.

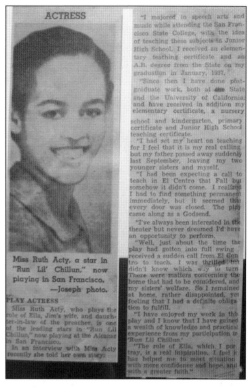

ACTRESS

"I majored in speech arts and music while attending the San Francisco State College, with the idea of teaching these subjects in Junior High School. I received an elementary teaching certificate and an A.B. degree from the State on my graduation in January, 1937.

"Since then I have done post-graduate work, both at the State and the University of California, and have received in addition my elementary certificate, a nursery school and kindergarten, primary certificate and Junior High School teaching certificate.

"I had set my heart on teaching for I feel that it is my real calling but my father passed away suddenly last September, leaving my two younger sisters and myself.

"I had been expecting a call to teach in El Centro that Fall but somehow it didn't come. I realized I had to find something permanent immediately, but it seemed that every door was closed. The play came along as a Godsend.

"I've always been interested in the theater but never dreamed I'd have an opportunity to perform.

"Well, just about the time the play had gotten into full swing I received a sudden call from El Centro to teach. I was thrilled but didn't know which way to turn. There were matters concerning the home that had to be considered, and my sisters' welfare. So I remained at home, rather disappointed, yet feeling that I had a definite obligation to fulfill.

"I have enjoyed my work in this play and I know that I have gained a wealth of knowledge and practical experience from my participation in 'Run Lil' Chillun.'

"The role of Ella, which I portray, is a real inspiration. I feel it has helped me to meet situations with more confidence and hope, and with a greater faith."

Miss Ruth Acty, a star in "Run Lil' Chillun," now playing in San Francisco. —Joseph photo.

PLAY ACTRESS

Miss Ruth Acty, who plays the role of Ella, Jim's wife, and daughter-in-law of the preacher, is one of the leading stars in "Run Lil' Chillun," now playing at the Alcazar in San Francisco.

In an interview with Miss Acty recently she told her own story:

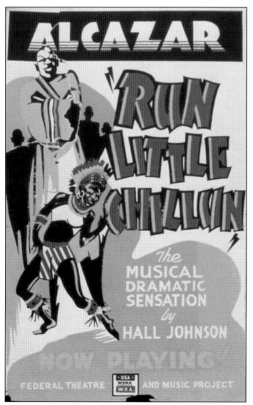

Pictured is a *Run Little Chillun* WPA poster for the San Francisco production at the Alcazar Theater. It also played at the Federal Building at the world's fair on Treasure Island. (George Mason University Libraries.)

Thomas C. Fleming said, "Nobody wanted relief work, because we thought of it as welfare. But when Roosevelt started the Works Progress Administration, WPA, in 1935, it was a lifesaver to me and many others who I knew then." When in his late 90s, he recalled working at the Bancroft Library, only remembering that it was probably for the Writers' Project guidebook to California. Later, he was founding editor of San Francisco's first black newspaper and longtime *Sun-Reporter* executive editor.

This photograph of the UC Berkeley campus is from *California: A Guide to the Golden State*. Compiled and written by the WPA Federal Writers' Project in 1939, it was part of the American Guide Series. As with the theater project, the writers' project came under attack from Texas congressman Martin Dies and his House Un-American Activities Committee. However, when federal funding stopped, the popular guides found support and were published in every state.

Berkeley was one of the cities to get its own book compiled by the writers' program of the Work Projects Administration in Northern California to commemorate its 75th anniversary in 1941. (The Works Progress Administration was renamed the Work Projects Administration in 1939.) The volume covers all aspects of Berkeley and is illustrated with photographs. The volume's foreword describes it as the "result of careful and exhaustive research"; it traces the area's history from 1772 to 1941.

Berkeley

THE FIRST SEVENTY-FIVE YEARS

COMPILED BY WORKERS OF THE WRITERS' PROGRAM OF THE
WORK PROJECTS ADMINISTRATION IN NORTHERN CALIFORNIA
CO-SPONSORS: CITY OF BERKELEY · BERKELEY FESTIVAL ASSOCIATION
PUBLISHED BY THE GILLICK PRESS · BERKELEY · CALIFORNIA · MCMXLI

Sidney Robertson Cowell is seen copying California Folk Music Project recordings for the Library of Congress. This photograph was taken in the project's office on Shattuck Avenue in early 1939. The WPA California Folk Music Project in Northern California, headed by Cowell, surveyed living folk music traditions found in California from late 1938 to early 1940. Cowell hoped that it would provide a prototype for a national folk music collecting effort. (LOC.)

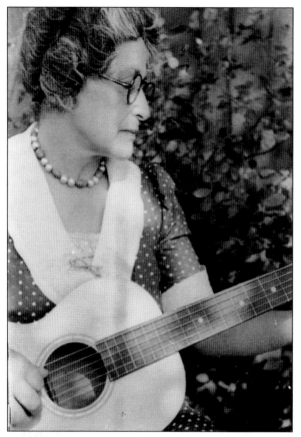

Lottie Espinosa is shown playing the guitar. Field materials document Espinosa performing Spanish songs from California on May 28 and August 19, 1939, and were collected by Cowell in Pacific Grove. Cowell researched and recorded the 35 hours of folk music in California, representing 16 English and foreign-language groups, primarily of European origin. (LOC.)

Cowell noted that the "pick is an eagle's feather from the Caucasus" when she documented performers of Armenian and Armeno-Turkish music on April 17, 1939, in Fresno. The California Folk Music Project operated from October 1938 to March 1940 and recorded 185 musicians. (LOC.)

This group portrait of Indian women at Pala Mission is described in the following manner: "Left to right: Senoras Pico, Valenzuela, de la Golsh, Ortega, Myers, and Acosta." There are, however, only five women visible in the photograph. The photograph forms part of a group of field materials documenting a group of six Native American women performing a mission song in Spanish on June 4, 1939, in Pala, California. (LOC.)

Scale drawings and sketches of some musical instruments were made by the project. This is a pencil sketch on brown paper. The entire project included folk music of immigrants who arrived in the United States from the turn of the century through the 1920s, American popular songs current from 1900 through 1940, old California songs from the Gold Rush era and before, old medicine-show tunes, songs from San Francisco's Barbary Coast, and ragtime. (LOC.)

On the back of this photograph, Cowell notes, "Mr. Prater, our wonderful Welsh photographer . . . who built the darkroom, did all our developing, printing, and enlarging for performers and the microfilm prints of California songsters from various libraries." She notes later, "He was a real pro, did everything I asked, sometimes before I asked, efficiently and quietly—everyone liked him, and his consistent calm and cheerfulness belied the Welsh reputation for excitability." (LOC.)

The California Folk Music Project employed an average of 20 people at 2108 Shattuck Avenue. Cowell notes on the back of the photograph: "6 or 8 workers are not shown: 3 draftsmen in another room, Sirvart Poladian and some others who preferred not to be photographed with the group. Sidney Robertson, the supervisor and field worker, is sitting just beyond the first window on left, against the partition." (LOC.)

Six

INNOVATIVE NEW DEAL PROJECTS

Nationally, the New Deal, especially the WPA, supported many specialized projects that allowed the innovation and resourcefulness of individuals and institutions to come to the fore. The projects developed in Berkeley give a sense of the broad scope of these efforts.

Initially, the Civil Works Administration employed artists at two Berkeley locations. The *Berkeley Daily Gazette* of January 8, 1934, reports that at 1836 Euclid Avenue and at 2229 College Avenue, workers, including women artists, were preparing relief maps of East Bay communities and "modeling animals and Indians," as well as preparing colored slides for the National Park Service. This project would later become the Western Museum Laboratory, located on Durant Avenue and then Fulton Street. It was a collaboration between the National Park Service, the WPA, and CCC that provided publicity and interpretive materials to national parks across the country.

UC Berkeley WPA projects were numerous. In a report on 1936–1937 WPA projects sponsored by the university, 25 departments are listed, some with multiple projects. WPA workers even worked on the cyclotron.

In 1935, the Wagner Act established the National Labor Relations Board and empowered workers to organize to improve their working conditions. The WPA set up a worker education program, offering some classes in Berkeley.

At the end of the decade, several major New Deal projects were completed in the Bay Area. The building of the Bay Bridge and the Golden Gate Bridge was commemorated with the 1939–1940 Golden Gate International Exposition held on Treasure Island (a man-made island created with funding by the WPA). Known as the "Pageant of the Pacific," it hoped to celebrate better relations among nations and peoples of the Pacific basin. Many Berkeley artists participated in the fair, including Jacques Schnier, Sargent Johnson, Helen Bruton (with sisters Esther and Margaret), Lulu Hawkins Braghetta, Robert Boardman Howard, David Slivka, Marian Simpson, John Emmett Gerrity, William Gordon Huff, and Edgar Dorsey Taylor. Their work embellished the fairgrounds and buildings, which were described as a new mode of architecture—Pacifica, which embodied motifs from both the eastern and western shores of the Pacific. In 1940, Elizabeth Ginno, Mine Okubo, and Emmy Lou Packard participated in the Art in Action exhibit.

Located on Durant Avenue in this photograph, the project became the Western Museum Laboratory when it moved to its Fulton Street location. This landmark building on Durant Avenue was originally a movie and vaudeville theater designed by Walter H. Ratcliff. (Kathleen Duxbury collection.)

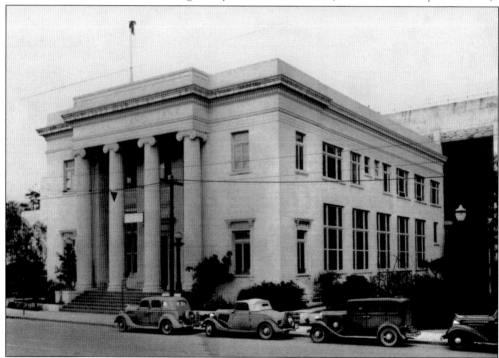

The Western Museum Laboratory was located in the former federal land bank on Fulton Street on the western edge of UC Berkeley, next to Edwards Field. The labor force consisted of Civilian Conservation Corps (CCC), National Park Service (NPS), and Works Progress Administration workers. There were generally about 100 people employed at the laboratory at any one time. Locally, it assisted WPA projects on the UC campus by providing photographic services. (John Aronovici collection.)

Artists are seen preparing interpretive materials and museum exhibits, which included murals, dioramas, and paintings for the National Park Service. Ansel Hall, a naturalist for the NPS, was the key figure in the early growth of the interpretive work of the NPS and in establishing the Western Museum Laboratory. (John Aronovici collection.)

WPA artist Elizabeth Ginno is at work at the Western Museum Laboratory. Previously, she had worked for the WPA in art education in the Oakland schools. She also participated in Art in Action at the GGIE in 1940. (John Aronovici collection.)

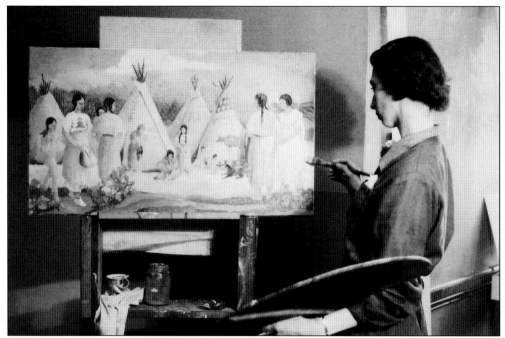

Painting at her easel, Elizabeth Ginno prepares a scene of a Plains Indian village for the National Park Service. In addition to working in oil, she also did prints and etchings. As a senior artist, she was paid $1.81 an hour. (When calculated for inflation, this would be a decent but not extravagant rate of pay today.) (John Aronovici collection.)

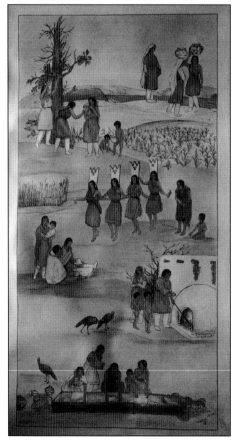

Artwork portraying various activities of Pueblo Indian women, painted by Elizabeth Ginno at the Western Museum Laboratory for the National Park Service, is pictured here. The artist gave attention to showing authentic detail. (John Aronovici collection.)

Elizabeth Ginno did this line drawing for the National Park Service at the Western Museum Laboratory. Though it was probably designed as a bookplate, it is not known how this piece was used. (John Aronovici collection.)

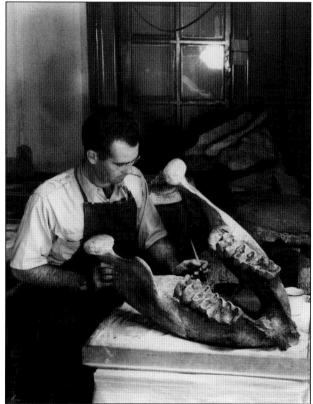

The caption for this photograph reads: "WPA worker preparing a fossil mammal jaw in the [University of California Museum of Paleontology (UCMP)] prep lab, Hearst Memorial Mining Building, circa 1939." WPA workers also helped the UCMP by preparing fossil specimens, cataloging and preparing the large Rancho La Brea collection, casting specimens, excavating fossils at the Black Hawk Ranch Quarry, preparing demonstrations for the GGIE, and other museum work. (UCMP.)

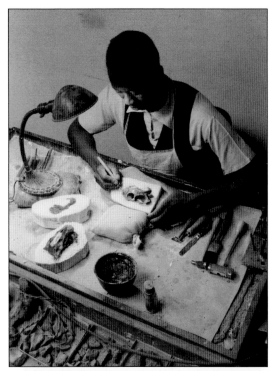

The image at left is captioned: "WPA worker Raphael Phoenix prepares a dicynodont skull from the Karoo Beds of South Africa. The skull took about one month to prepare." The image below is captioned: "WPA worker finishing the preparation of a mammal-like reptile skull from the Karoo Beds of South Africa." Besides working within campus buildings, WPA workers did fieldwork as well. WPA photographers also documented numerous projects supported by the WPA on the UC campus. Unfortunately, the high fees now charged for these photographs by the Bancroft Library prohibited their inclusion in this volume. (Both, UCMP.)

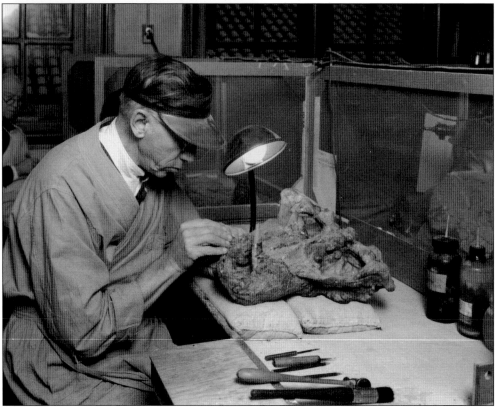

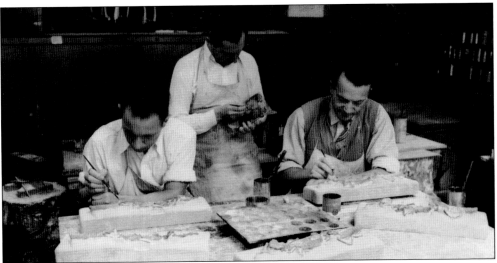

This image is captioned: "Valuable assistance to the museum and the field of paleontology is being rendered by WPA workers in casting type and rare specimens. This work makes it possible to exchange these casts with other institutions for study and display. Casts of a primitive crocodilian skeleton are being colored to match the original." WPA workers were employed in many campus laboratories and even assisted with work on the cyclotron in the physics department. (UCMP.)

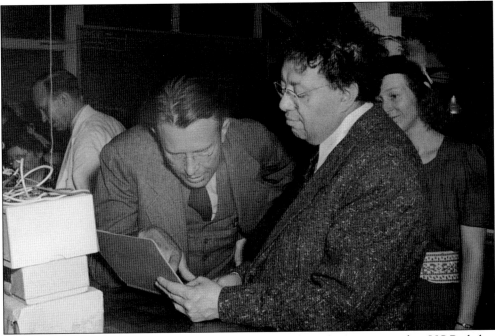

Diego Rivera (foreground) was interested in the highly technical atomic research at UC Berkeley. He is seen here with Ernest O. Lawrence and artist Emmy Lou Packard at the UC Berkeley Radiation Laboratory in 1940. In his work, Rivera portrays traditional art and culture as well as modern technology. Ernest O. Lawrence in a letter described the assistance WPA workers provided the Radiation Laboratory in its cancer treatment research. He told how WPA employment benefited society by providing employment and "to a much greater extent by the results of the work accomplished." (Bancroft Library.)

The National Labor Relations Act had given workers the right to unionize, and the WPA set up programs for labor education. Although these posters advertise the New York workers education project, the Pacific Coast School for Workers in Berkeley held a summer session in 1938 that included a class in labor journalism and provided a library for study. A *Time* magazine report on August 1, 1938, states that the "WPA-Workers' Education project educates workers in their spare time. Across the country 60,000 laborers attend classes before and after hours in mining camps, sugar-beet shacks, cotton warehouses, union halls, construction sheds . . . In States where anti-labor sentiment is strong, educational activities carried on under sponsorship of labor unions is highly suspect, is sometimes suppressed." (Both, LOC.)

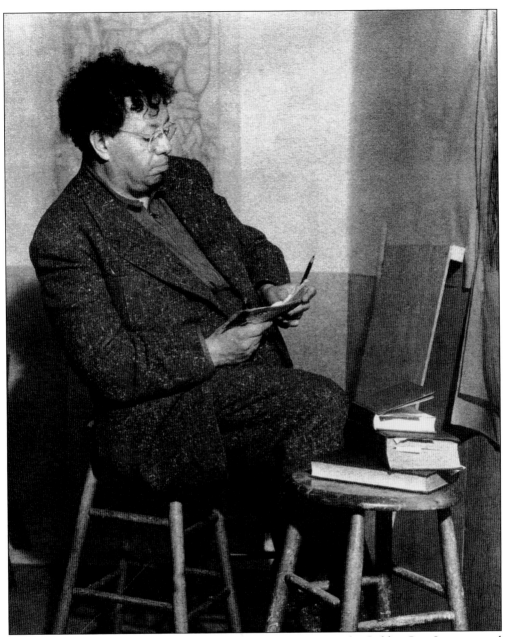

Diego Rivera prepares studies for his mural *Pan American Unity* at the Golden Gate International Exposition in 1940. Rivera was part of the Art in Action program during the second year of the fair. Visitors could observe artists doing their work and interact with them, and many New Deal artists participated. Rivera's work influenced many artists during the 1930s and 1940s. Many artists assisted him on his large projects, including Emmy Lou Packard. (For a short time, Rivera had stayed at the Packard family house in Berkeley.) By the close of the fair, Rivera was not finished and worked for two additional months in the empty exhibit hall. During the painting of the mural, Frida Kahlo arrived in San Francisco, and on December 8, 1940, Rivera's 54th birthday, Kahlo and Rivera were married for the second time. (Scan of original silver gelatin photograph, © 1940, 2014 Rondal Partridge Archives.).

This portion of the *Pan American Unity* mural painted by Diego Rivera during Art in Action at the GGIE on Treasure Island in 1940 shows Frida Kahlo in the center and actress Paulette Goddard on the right. Rivera said, "My mural which I am painting now—it is about the marriage of the artistic expression of the North and of the South on this continent." The mural is now at City College of San Francisco.

This photograph was taken at Japan Day in September 1940 at the Golden Gate International Exposition (GGIE) on Treasure Island. The island was created from bay fill by the PWA during the building of the Bay Bridge. The GGIE drew participation from countries throughout the Pacific basin and emphasized the diversity and unity of people in the region. It is poignant to think that in just over a year the United States would enter World War II and the lofty ideals of the GGIE would be quickly forgotten. Yoshiko Yoshida, a native of California and a Berkeley resident, is standing at the right. (The lantern and rocks are now in the Japanese garden section of the UC Botanical Garden in Berkeley.) Although an American citizen, she was one of 120,000 Japanese Americans interned during the war. She was first housed at the Tanforan racetrack in San Mateo and then sent to the Topaz concentration camp in the high desert near Delta, Utah. (Yoshiko Yoshida collection.)

This print of a woman from Finland with wheat under her arm is one of a series of 75 costume prints done by Elizabeth Ginno as part of Art in Action. She depicted people of various cultures in their traditional dress. Her earlier experience working in the theatrical costuming business undoubtedly contributed to her detailed portrayals of people attending the fair. (John Aronovici collection.)

Elizabeth Ginno also did a series of flower prints at Art in Action. Here is her depiction of California poppies. (John Aronovici collection.)

Elizabeth Ginno worked at the fair, but she also visited with her son John Aronovici, who still has vivid memories of the fair. It was a big event—an extravaganza of entertainment, culture, and education—for any Bay Area resident and the many visitors from throughout the United States and around the world. (John Aronovici collection.)

This etching by Elizabeth Ginno is of Carmen Miranda, who was one of nine million visitors to the fair in 1940. That same year, the Brazilian actress had just appeared in her first American movie, *Down Argentine Way.*

The Tower of the Sun, shown is an etching by Elizabeth Ginno, was designed by architect Arthur Brown Jr. Bathed in light at night, the fair could be seen throughout the Bay Area. By the time the lights dimmed in 1940, the United States was on the cusp of war. The fairgrounds were demolished except for the three permanent buildings, and the island became a naval base during World War II.

Mine Okubo graduated from UC Berkeley and was a WPA artist and mural assistant for Diego Rivera. She was interned in Topaz, Utah, as a result of Executive Order No. 9066. She taught art and was art editor of *Trek* magazine there. Postwar, she wrote and illustrated *Citizen 13660*, the first account of life in a concentration camp for Japanese Americans, taught art at UC Berkeley, and spent her later years in New York City. (Library of Congress.)

Seven

A Legacy for the Future

Within a decade, the New Deal put 15 million people back to work and sought to lay the groundwork for a new society. A multitude of social programs educated and elevated Americans everywhere. An extensive environmental restoration agenda planted more than three billion trees and revitalized both forests and depleted farmland. Vast projects provided clean water, waste treatment, and electricity nationwide. The New Deal's legacy includes thousands of schools, museums, parks, hospitals, roads, airports, post offices, and public buildings, many of them adorned by artists and craftspeople.

Today, many decry the sorry state of America's infrastructure, which clearly indicates the need to mount an effort akin to that of the New Deal. People have forgotten that this type of focus on national need is possible. This all begs the question, "Is it time now for a *new* New Deal?"

As seen with Berkeley's example, the New Deal legacy surrounds people today, but its overall impact both then and today goes largely unrecognized. A few states have museums dedicated to the CCC, and a few New Deal buildings serve as museums. A number of major museums own collections of New Deal art but, with few exceptions, have not displayed these works in decades. However, there is no museum in the United States dedicated to the art, architecture, and social programs of the New Deal itself, nor is there a memorial to the veterans of the peacetime armies who built the infrastructure and social programs Americans still depend on and enjoy today.

It is the author's hope that a New Deal museum would showcase the creativity and innovation of New Deal programs, serve to rekindle pride in government, and remind the public of what can be achieved when government mobilizes to help working Americans through hard times. This wonderful legacy of the New Deal must not stay frozen in time. It needs citizens' improved awareness to protect its ongoing utility and beauty and their vision to use its example to once again create a society based on the ethic of providing for all Americans.

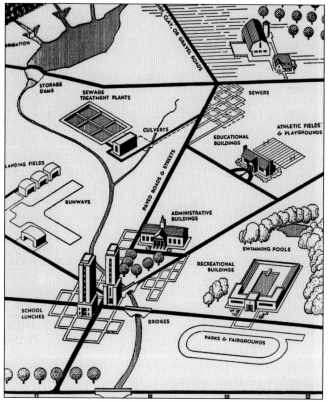

The graphic at left represents the types of infrastructure constructed during the New Deal, most of which have representative examples in Berkeley or nearby. Berkeley, like thousands of communities across the United States, still depends upon these structures. Although portraying the economic impact of a PWA project, the flow chart below applies to any of the New Deal construction projects and illustrates their economic impact. The American Society of Civil Engineers is an organization committed to protecting the health, safety, and welfare of the public, and it is equally committed to improving the nation's public infrastructure. Its report card depicts the condition and performance of the nation's infrastructure. America's grade for 2013 was D+.

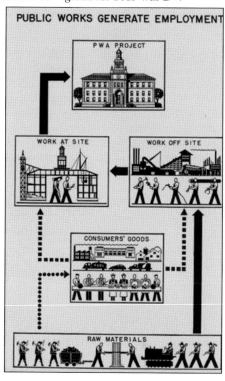

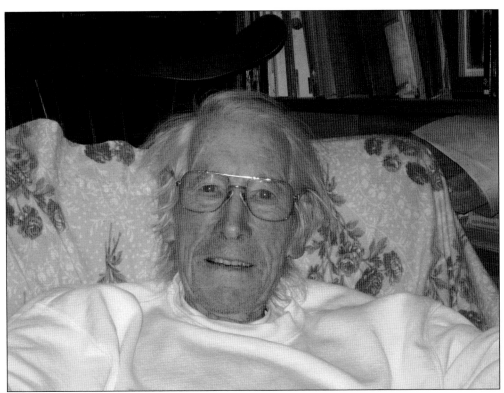

Travis Lafferty, pictured in April 2010 at his home in Oakland, California, joined the CCC. Like other "CCC boys," Travis was very proud of his CCC service and later in life interviewed and received written reminiscences from fellow CCC workers. In 1990, he compiled these into a self-published book titled *Another Day, Another Dollar: Remembering the CCC, 1933–1942*. He and his wife met as UC Berkeley students; she had a job with the NYA.

Milton Wolff, a CCC boy, went to Spain in the late 1930s to fight against the dictator Franco. The last commander of the Abraham Lincoln Brigade, Wolff was described by Ernest Hemingway: "as brave and as good a soldier as any that commanded battalions at Gettysburg." Like others who fought in Spain, he was labeled a "premature antifascist" on return, and he continued to support progressive and antiwar causes for the rest of his life. He stated, "Activism is the elixir of life." (Richard Bermack.)

Archie Green got an NYA job at UC Berkeley, and he enlisted in the CCC after graduation. He then began working as a shipwright in San Francisco. His interest in labor folklore followed on the heels of the documentary work of the WPA's Federal Writers' Project. Archie got a congressional bill passed establishing the American Folklife Center within the Library of Congress. Archie stated, "FDR was my hero. . . . He was for the workingman."

This press conference was held on May 3, 2013, to draw attention to the potential sale of the Downtown Berkeley Post Office to a private party. The building contains a New Deal relief and a mural. Pictured, from left to right, are Loni Hancock, state senator; Nancy Skinner, state assemblywoman; Ying Lee, former congressional aide (at microphone); Kriss Worthington, Berkeley City Council; and Tom Bates, mayor. Berkeley has led the effort to halt privatization of the USPS.

The original UN Charter was printed at the UC Printing Plant in June 1945. It had taken World War II to bring the nations of the world together with the hope for establishing permanent world peace. The Universal Declaration of Human Rights adopted three and half years later reflected the principles of President Roosevelt's January 1944 "Second Bill of Rights" speech which proposed the inherent economic rights of employment, medical care, housing and education

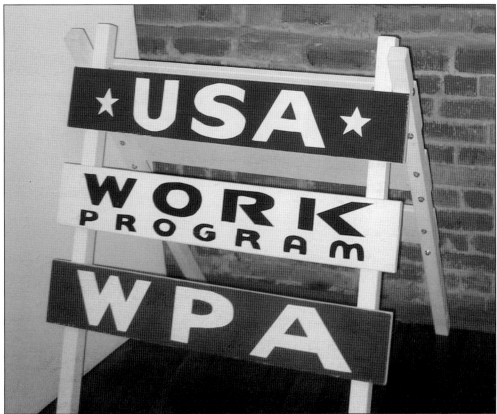

Harvey Smith, Carla Woodworth, Doug Minkler, and Jos Sances created this *WPA Sawhorse* in 2011. It is a silkscreen-on-wood replica based on original in the collection of the Berkeley Historical Society. This sawhorse is a symbol of the millions of jobs created under the FDR administration's "alphabet soup" agencies—the CCC, CWA, PWA, WPA, NYA, and others—that left a legacy of still-used infrastructure, public artworks, and social programs throughout the United States.

BIBLIOGRAPHY

Advisory Council on Historic Preservation, *Preserving Historic Post Offices: A Report to Congress*. Washington, DC: Advisory Council on Historic Preservation, 2014. (Available at www.achp.gov)

Alter, Jonathan. *The Defining Moment: FDR's Hundred Days and the Triumph of Hope*. New York: Simon & Schuster, 2006.

Breiseth, Christopher and Kirstin Downey, editors. *A Promise to All Generations: Stories and Essays about Social Security and Frances Perkins*. Newcastle, ME: Frances Perkins Center, 2011.

Burns, Sean. *Archie Green: The Making of a Working-Class Hero*. Urbana-Champaign: University of Illinois Press, 2011.

Cohen, Stan. *The Tree Army: A Pictorial History of the Civilian Conservation Corps, 1933-1942*. Missoula, MT: Pictorial Histories Publishing Co., 1980.

Downey, Kirsten. *The Woman Behind the New Deal: The Life and Legacy of Frances Perkins, FDR's Secretary of Labor and His Moral Conscience*. New York: Random House, 2009.

Federal Writers Project of the Works Progress Administration, Introduction by David Kipen. *California in the 1930s: The WPA Guide to the Golden State*. Berkeley: University of California Press, 2013.

Flynn, Kathy. *The New Deal: A 75th Anniversary Celebration*. Layton, UT: Gibbs Smith, 2008.

Leighninger Jr., Robert D. *Long-Range Public Investment: The Forgotten Legacy of the New Deal*. Columbia, SC: University of South Carolina Press, 2007.

Myers-Lipton, Scott. *Rebuild America: Solving the Economic Crisis Through Civic Works*. Boulder, CO: Paradigm Publishers, 2009.

Quinn, Susan. *Furious Improvisation: How the WPA and a Cast of Thousands Made High Art out of Desperate Times*. New York: Walker Publishing Company, 2008.

Taylor, David A. *Soul of a People: The WPA Writers' Project Uncovers Depression America*. Hoboken, NJ: John Wiley & Sons, 2009.

Taylor, Nick. *American Made: The Enduring Legacy of the WPA When FDR Put the Nation to Work*. New York: Bantam Books, 2008.

Walker, Richard and Gray Brechin. "The Unsung Benefits of the New Deal for the United States and California." UC Berkeley Institute for Research on Labor and Employment, 2010.

Zakheim, Masha, with photographs by Don Beatty. *Coit Tower San Francisco: Its History and Art*. Volcano, CA: Volcano Press, 2012.

DISCOVER THOUSANDS OF LOCAL HISTORY BOOKS FEATURING MILLIONS OF VINTAGE IMAGES

Arcadia Publishing, the leading local history publisher in the United States, is committed to making history accessible and meaningful through publishing books that celebrate and preserve the heritage of America's people and places.

Find more books like this at
www.arcadiapublishing.com

Search for your hometown history, your old stomping grounds, and even your favorite sports team.

New Deal
Organizations

The Living New Deal (www.livingnewdeal.org) is dedicated to cataloging the achievements of the New Deal and collecting the stories of those whose lives were touched by the New Deal. Likewise, its sister organization, the National New Deal Preservation Association (www.newdeallegacy.org), links individuals, agencies, facilities, and programs to promote the identification, documentation, and preservation of New Deal sites and the education of people about the New Deal. They welcome involvement from the broader community to identify New Deal sites, to share firsthand stories of involvement in New Deal programs from still-living participants and from family members, and to advocate for the preservation of New Deal structures and programs.

As the writing of this book concludes, the struggle to prevent privatization of the United States Postal Service continues. Our New Deal organizations are particularly concerned about the preservation of New Deal post offices and artwork, but this concern also extends to the loss of public sector jobs and services and the important role post offices play as a gathering place in our communities. Contact either organization about more details on this issue or other New Deal questions.

Companion organizations working on post office preservation include the Save the Berkeley Post Office (www.savethebpo.com), the National Post Office Collaborate (www.nationalpostofficecollaborate.com), and Save the Post Office (www.savethepostoffice.com), the site that compiles information from across the nation.

The story of Berkeley's New Deal legacy represents a microcosm of what has been left to us in every community throughout the United States. It is worthy of our collective efforts to discover, document, and preserve. Its lessons inform our current reality and provide the knowledge of an American past where we as a nation strove to take care of everyone in need—where the public sector was supported rather than a regime of austerity. This is not a utopian dream of the future; we had that ethic and reality but seem to have forgotten it. We can still use our "New Deal yardstick" to see how current public policy measures up. We can continue our involvement and return to a truly caring society. However, an essential lesson of the New Deal is that it is ultimately not up to our political figures to make it happen. It may be a big responsibility, but it falls upon each and every one of us.